Decorative PAINTING

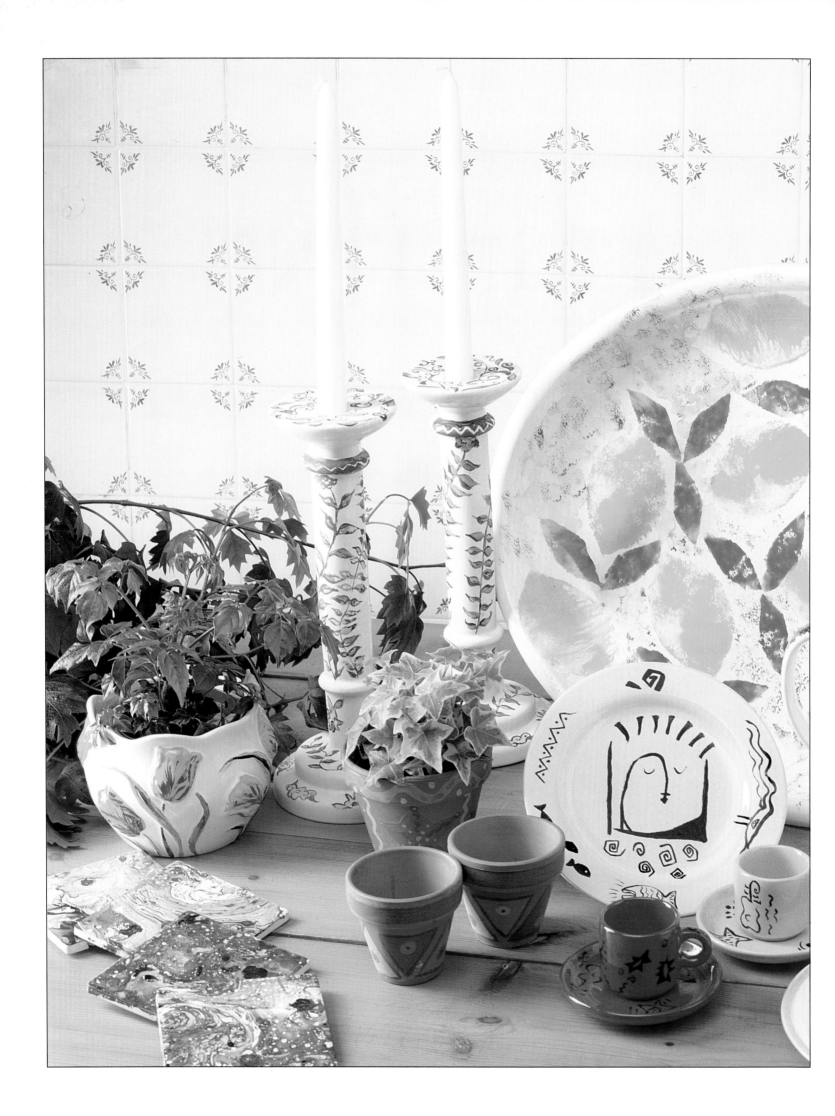

Decorative PAINTING

Letty Oates

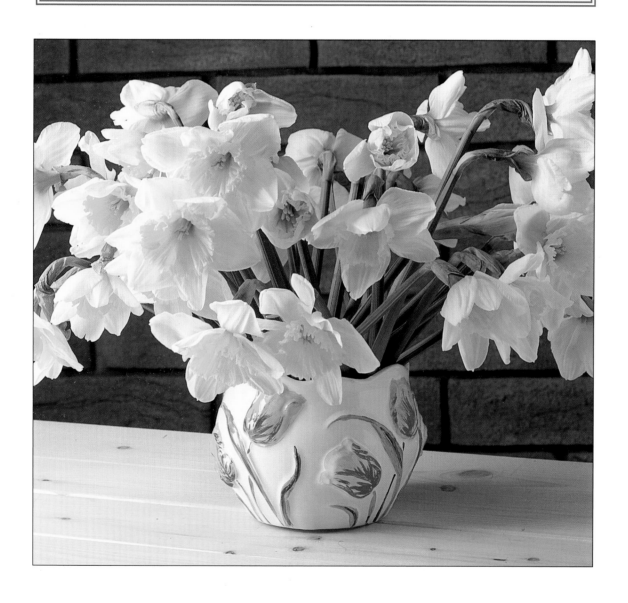

JG PRESS

The author and publishers wish to thank the following for their generous product contributions to this book.

Inscribe
The Woolmer Industrial Estate, Borden, Hants. U.K.
For acrylic craft paints.

Dulux
For satin wood and emulsion paints.

MFI
For chest of drawers.

Philip and Tacey
Andover, Hants. U.K.
For glass, acrylic, ceramic and silk paints.

Dylon International Limited
Worsley Bridge Road, Lower Sydenham, London SE26 5HD. U.K.
For fabric pens and paints.

Pelikan U.K.
Newcombe Way, Orton, Southgate, Peterborough PE2 0UJ. U.K.
For paints and brushes.

The Stencil Decor
For stencil blanks and the goose stencil used on the Blackboard Door.

The author wishes to thank Labeena Ishaque for hand modelling and for making many of the projects in this book.

Published in the USA by JG Press
Distributed by World Publications, Inc.

The JG Press imprint is a trademark of JG Press, Inc.
455 Somerset Avenue
North Dighton, MA 02764

Copyright © 1995 Regency House
Publishing Limited

ISBN 1-57215-099-8

Printed in China.

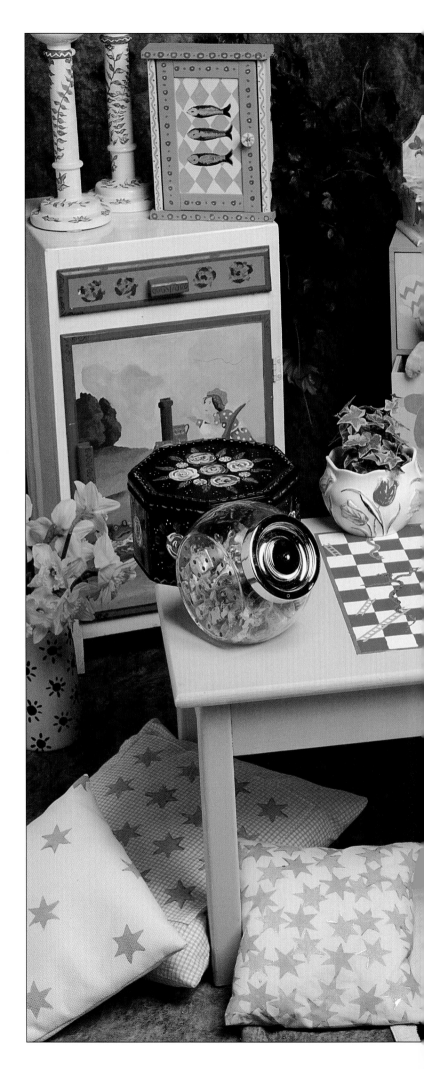

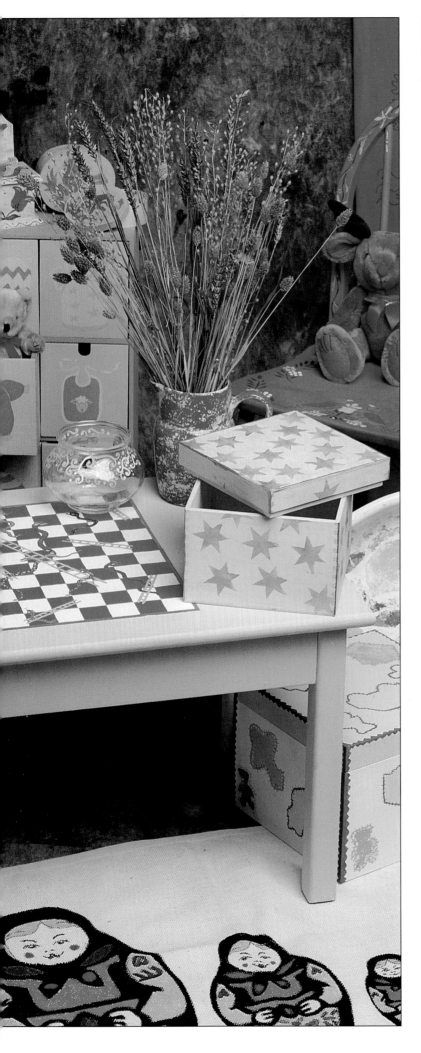

Contents

Introduction

Decorative Painting *shows you how to personalize readily available shop-bought items. This means that you can create designer style without spending a fortune or a great deal of time.*
It contains ideas for painting and decorating ceramics, fabrics, glass, metal, and wooden objects.
The techniques used include painting, stencilling, marbling, stamping and painting on silk.
The paints used have been developed with both professional and domestic consumers in mind. They do not need complicated fixing or setting procedures and the end result is excellent both in terms of quality of colours and finish.
Some of the ideas in the book can be used to revamp existing objects or to make new and stylish creations. For example, an old sweet tin was sprayed black and, in the style of the canal narrow-boats, was painted to give it a new lease of life as an attractive storage tin. There are 29 projects in this book, all with step-by-step drawings or photographs. Learn how to decorate furniture, kitchenware, rugs and even items of clothing. Most of the projects can be done in an evening or even less. Happy painting!

Letty Oates

Methods and Ways of Working

Design Inspiration

You may wish to follow the designs in this book, but as you become more confident in using the techniques, you will surely see other ideas to adapt or copy for yourself.

Ideas can come from a wide range of sources – holidays, books, museums and galleries have provided inspiration for many of the great designers. It may be helpful to know that very few designs are completely original and the final product can often be very different from the initial concept.

Be prepared to experiment and try to be adventurous about developing your own techniques.

What to paint

The choice of objects to paint is almost limitless – ceramics, fabrics, glass, metal, wooden objects and old furniture. Painting enables you to add unique touches to your home and to develop your own personal taste.

Everything you need to get started is easily available – there is a product for every purpose, from ceramic and glass paints to traditional household and fabric paints.

Once developed, coordinating themes can be carried through to lampshades, vases, candlesticks and boxes to put the final decorative touches to your house.

Paints

Although oil-based paints and emulsions are used to paint larger wooden objects such as doors and skirtings, acrylic paints are ideal for decorating smaller articles, as well as a wide range of surfaces such as tables, chests, boxes, and even walls.

Acrylics are available in a wide range of colours, are easy to use, fully waterproof, fast drying and have a rich, glossy finish. Surfaces do not have to be prepared, as they do for gloss paints, but can be painted directly onto the wood.

Stencilling

Stencils can be made from a variety of materials including plastic sheet, paper, waxed or manila paper and clear acetate. Metal stencils are used in commercial production though manila paper was once the traditional material. Today, the most popular material is clear acetate. It has the advantage of being transparent, thus making it easy to line up designs and get them into register. It is a flexible material and will bend round curved surfaces. If looked after properly, an acetate stencil should last for years. Another transparent material, excellent for making stencils, is plastic low tack peel or masking material which is useful if you wish to stencil onto cups, plates or any form of china. It has good adherence and the paint will not seep underneath the stencil. To draw on clear acetate you need a permanent marker.

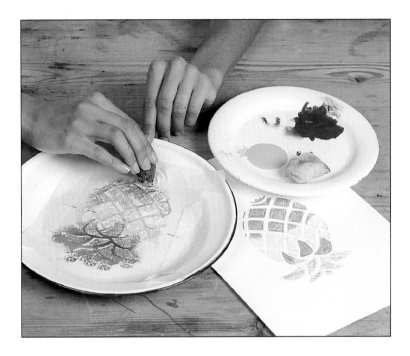

Cutting Stencils

A craft knife with a sharp point is best for cutting stencils. Cutting blades should be fine and never heavy duty. Hold the stencil knife as you would a pen and cut towards you. With your free hand, turn the stencil as you go. Move the stencil and try to cut continuously so that the outline is not broken. If you make any mistakes mend them with clear adhesive tape on either side of the stencil.

Cutting Mats or Boards

Acetate can be cut on a sheet of plain glass approximately $1/4$ inch thick. A good investment is a self-healing mat: this has a special surface which closes up immediately after cutting. The only drawback is that the knife tends to drag on this more than on glass. An old drawing board could also be used for cutting.

Preparing Backgrounds for Stencilling

A selection of medium to fine grade sandpaper is indispensable for preparing wooden and other rough surfaces or if you wish to rough up a smooth or varnished surface.

Untreated woods should be primed and then undercoated. If you wish to stencil onto raw wood it is best to stain or seal it first.

Before stencilling onto fabric you should first wash it to remove any finish or dressing from it.

Paints for Stencilling

Acrylics are the most versatile of paints. They are quick drying and can be applied to most surfaces. They come in a variety of bright colours and give a glossy rich finish. Acrylic paints are not suitable for use on glossy surfaces.

Emulsion paint may be used for stencilling as it is in many of the projects in this book. As a final protection it should be covered with a coat of clear varnish. Eggshell finish is suitable for stencilling onto wooden surfaces. Oil-based stencil pencils are a wonderful invention enabling the most nervous to stencil onto a wall without fear of the colour running. To use these, the seal is first broken off the end of the pencil by rubbing it onto rough paper. The colour is rubbed onto a corner of the stencil and the stencil brush rubbed into it to collect the colour. A circular movement is used to transfer the colour from the brush through the stencil. Colours may be blended but a fresh brush should be used for each colour to prevent them from becoming muddy-looking.

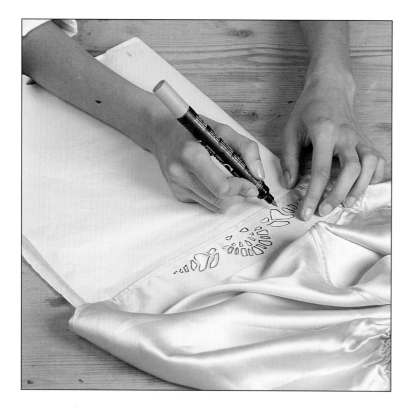

Fabric Stencilling

There is a huge array of fabric pens, paints, powders, glitters and plastic paints on the market, most of which can be used for stencilling. A vanishing textile marker is useful for drawing a design on fabric which will fade when paint is applied over it and outlines can be drawn in with a gutta outliner pen. When stencilling a fabric, it should be washed, ironed and then taped to a board before starting to stencil. Once the colour is dry, the most usual way to fix the cloth so that it will withstand washing is to iron it on the reverse.

Applying the Colour

There are different techniques of applying colour when working with stencils. It is best to apply a little colour at a time. Most mistakes are due to using too much paint which then seeps underneath the stencil. The most popular way of applying paint is to use a stencil brush. This is a flat-headed brush. They come in a variety of sizes and grades, they may have long or short handles and can be made of synthetic or natural materials.

Sponges are also used to apply colour and are ideal when working on a large, open, design. A sponge can also be used to produce a mottled area of colour.

Reversing a Stencil

A stencil may be reversed or flipped to create a mirror image. If you are going to do this, make sure that all the paint has been cleaned off what was the front of the stencil and that it is perfectly dry. Remember that this cannot be done with a stencil which includes numbers or letters.

Painting on Ceramics

There are many kinds of ceramic paints. These include ones that are water- and solvent-based, both of which can be painted onto glazed china. They can also be used on unglazed china which is to be kiln-fired. As specifications constantly change, it is important to check the manufacturer's instructions when buying ceramic paints. Many of them are only suitable for decorative use. These should never be used where they will come into contact with food or drink. They are air dried and should only be washed by hand in the gentlest of mild washing up liquids. They may be further protected with a coat of clear varnish.

Some water-based paints may be baked in a domestic oven to harden them. Water-based ceramic paints tend to have a brighter finish than solvent-based ones but they come in a smaller range of colours. They can be diluted with water and dry in about 4 hours. They can be baked in a domestic oven to harden them further. As temperatures and baking times differ from product to product, it is best to check the manufacturer's instructions before starting.

In addition to ceramic paints, you can use glass paints on ceramics. These are translucent and have the look of boiled sweets when used on glass.

Beginners' Tips for Ceramic Painting

1 Before you start, always have plenty of greaseproof paper or newspaper at hand on which to place the finished articles.
2 Always make sure the item to be painted is clean and free of grease. Wash it in warm, soapy water or clean it with white spirit before you begin.
3 Make sure you have sufficient white spirit to wash brushes and dilute paint. You will need jam jars and lids for mixing.
4 Keep at least two lint-free cloths beside you. One should be soaked in white spirit to rub out mistakes, the other kept dry to rub off any residual smears.
5 Never overload the brush unless you want blobs of paint to be part of the pattern.
6 When spraying, sponging, or marbling wear rubber gloves as the paint is not easily removed from skin. Buy fine surgeon's gloves or, alternatively, apply a barrier cream.
7 Have a range of brushes, from fine to thick, to make broad or narrow brush strokes. If possible, have different brushes for water- and solvent-based paints.

Glass painting

This is a general term for any type of painted design applied to a glass surface. It is a versatile way of decorating glassware and can be easily adapted to your own requirements. Everything from storage jars and drinking glasses to doors and windows can be enlivened by this simple, yet effective, technique.

Glass paints are available from art and craft shops. The paint is transparent and the effect when dry is very similar to that of coloured glass. As the colours are viscous, they don't run, which makes them easy to use on vertical surfaces. To achieve an opaque effect, you could use

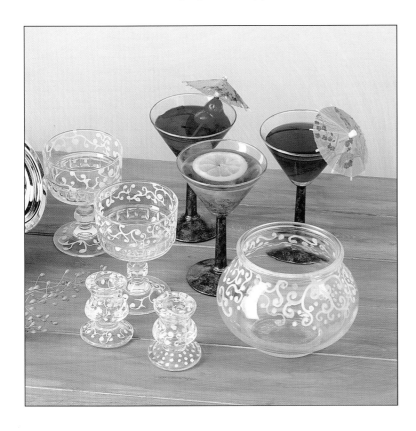

ceramic paint and for large, flat surface areas French enamel varnish is ideal: both are generally available in art and crafts shops. In fact, virtually any type of paint can be used to create various effects. However, because the surface of glass is smooth, shiny and non-porous, most paints will eventually chip and flake off. So, if your work is mainly for decoration and doesn't need washing too often, there is a wide choice of paints available to you.

Beginners' Tips for Glass Painting

1. *To outline a design* it is easiest to purchase a lead relief non-toxic outliner, which can be applied directly from the tube nozzle. Take care that the outline is completely joined so that the paint cannot seep through. The outliner takes 2-3 hours to dry.
2. *To colour in the main areas of the design,* once the relief outline is dry, apply the glass paint with a clean, soft sable brush well loaded with paint. The paint will flow onto the glass without leaving brush strokes. Push the paint gently into the edges. The paint can be thinned with white spirit, if necessary.

3. *To make paler shades,* mix stained glass varnish with the paints or mix the paints together. You can also mix solvent-based glass and ceramic paints together to increase variety.
4. *Candles.* Stained glass and ceramic paints can also be used to paint candles. Allow 48 hours to dry and give the candles a final protective coat by dipping them in clear melted wax.
5. It is vital to have both the brush and the glass surface clean. When using solvent-based glass paints, clean brushes in white spirit and dry before you start work – water in the brush will produce bubbles in the paint.
6. Use the paints with stencils, sprays and for marbling.

Useful Equipment

Sponge
Use small and large pieces for sponging on paint. Cut sponge to make shapes, for example, a toy or a heart or flower shape which can be used to 'print' onto a surface.

Chinagraph Pencil
Draw the design onto ceramics with this wax pencil. You can use it on areas which you wish to protect or mask off from the paint.

Bowl
A large washing up bowl filled with water is used to float solvent-based ceramic or glass paint for marbling.

Varnishes

Ceramic varnish is designed for use on pottery and china; as ceramic paints are not hard wearing it is a good idea to protect your designs with a coat of ceramic varnish.

Polyurethane varnish is suitable for wood and is therefore ideal for stencils on tables and chairs. It is available in matt or gloss finish.

Patina varnish can create a high gloss, lacquer effect on wood.

Crackle varnish is applied to tacky patina varnish, the different drying rates causing the varnish to crack and create an antique effect.

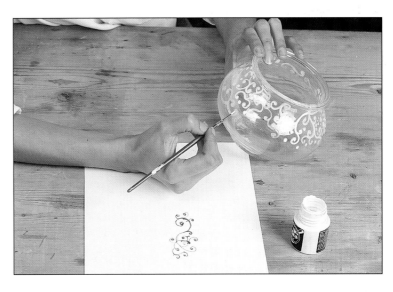

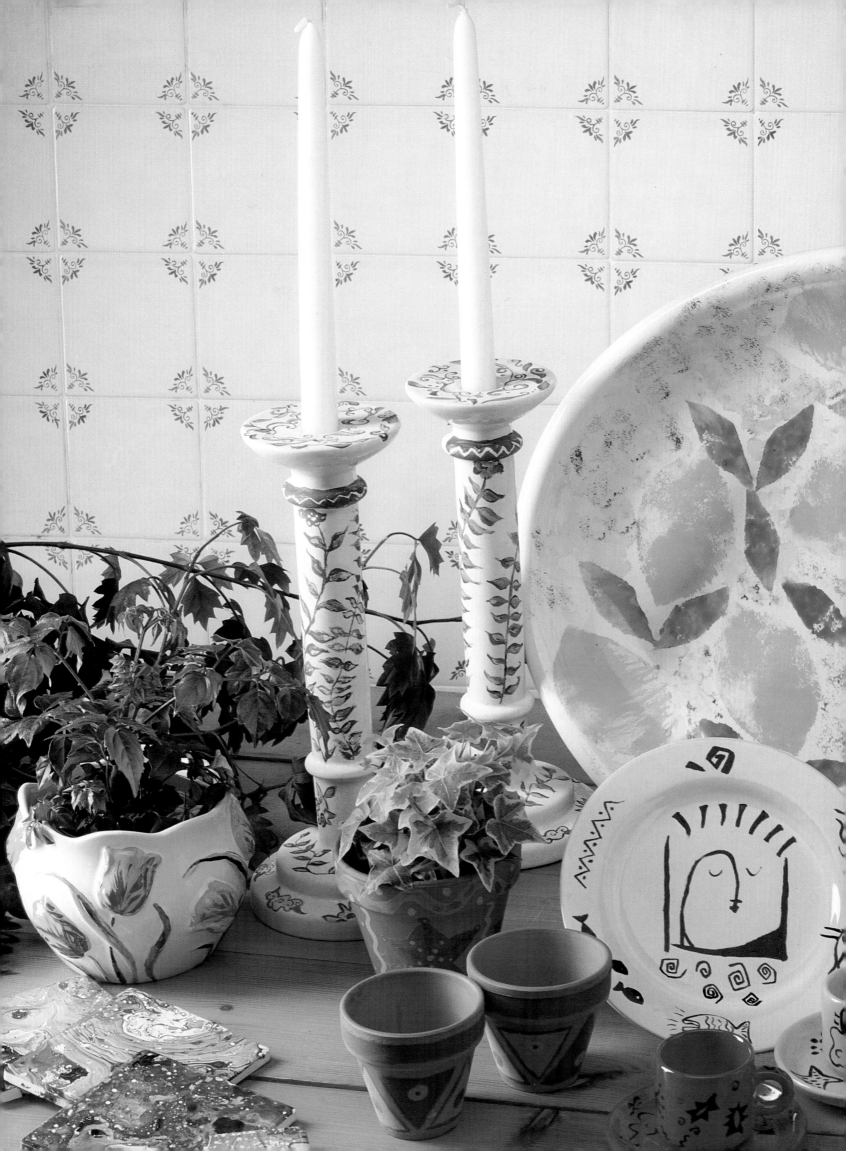

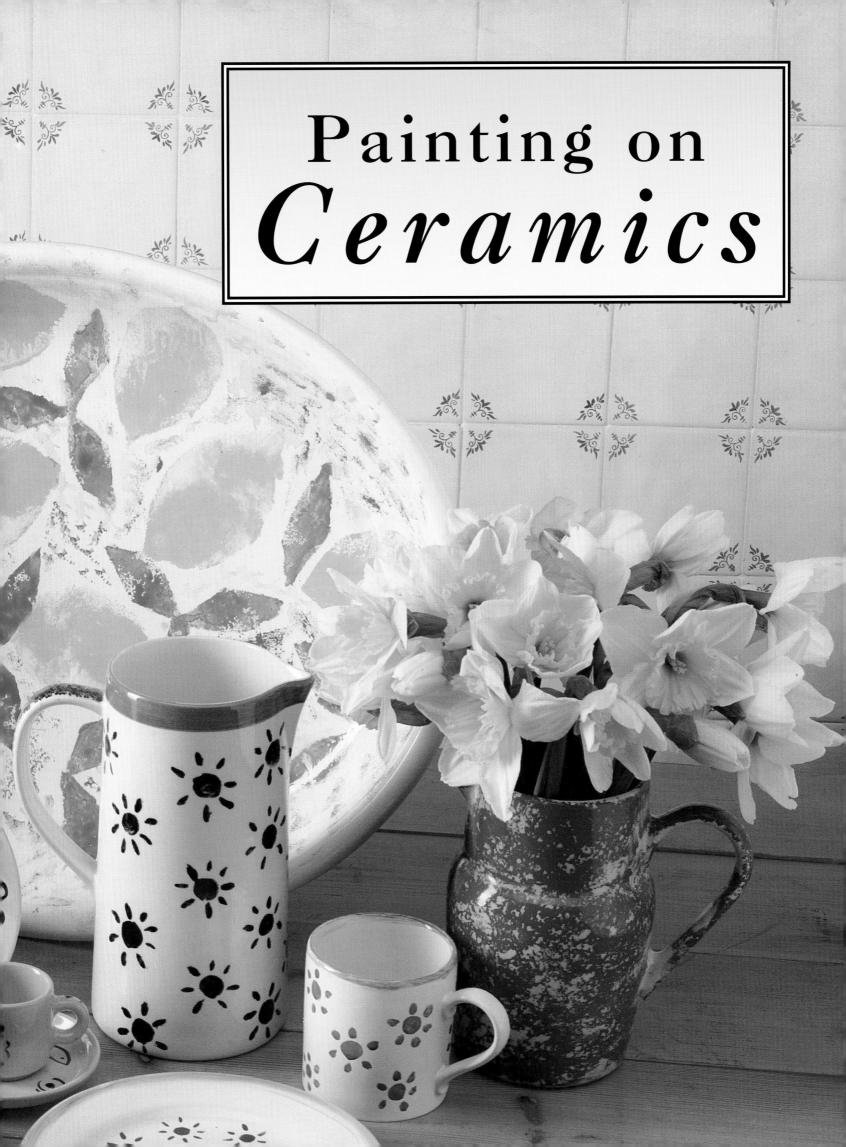

Painting on *Ceramics*

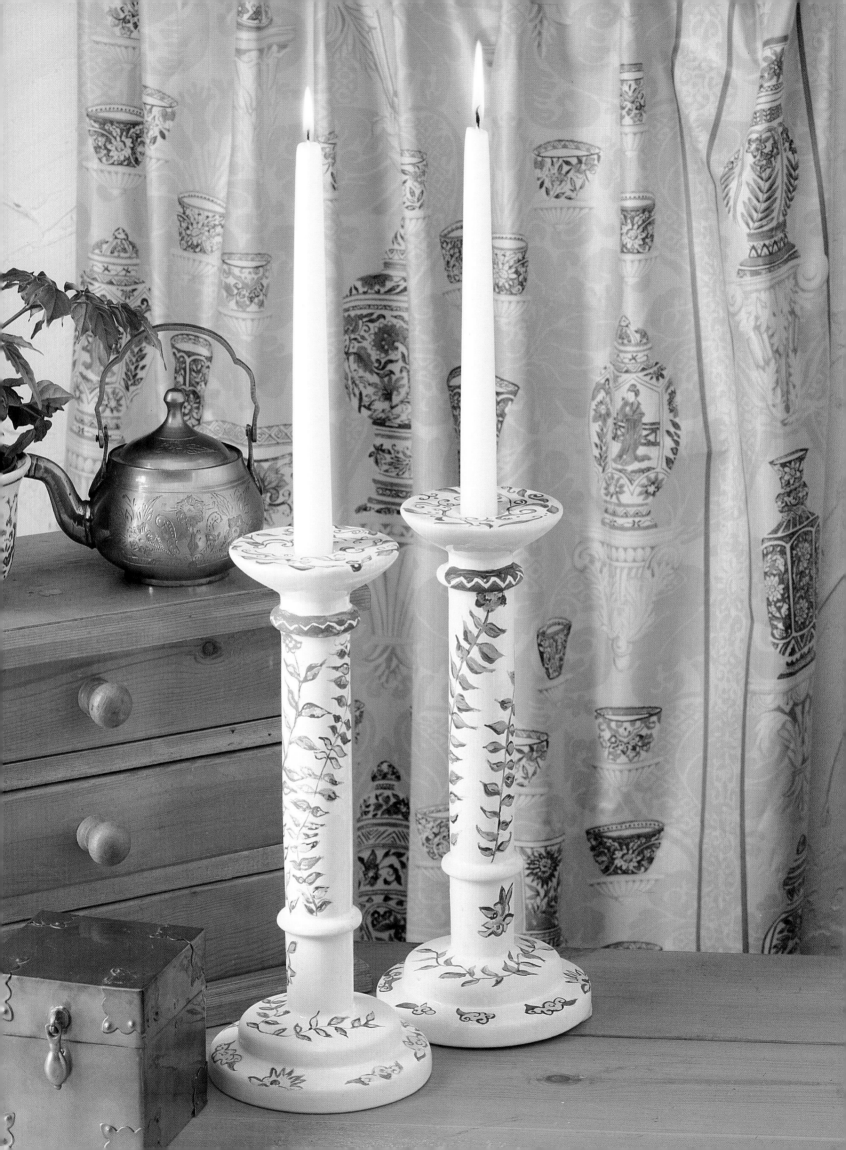

Candlesticks

This fine pair of candlesticks has been decorated to complement the décor of a sitting room. The design on the candlesticks is taken from a section of the furnishing fabric. A matt sponged background is first applied, and, when this is dry, a fine line leaf design is hand painted in a contrasting shiny ceramic paint.

Tools and materials
Pair of white candlesticks
Matt paint in pale yellow
Sponge, ceramic paint in blue
Fine paint brush
Fabric from which to copy a design

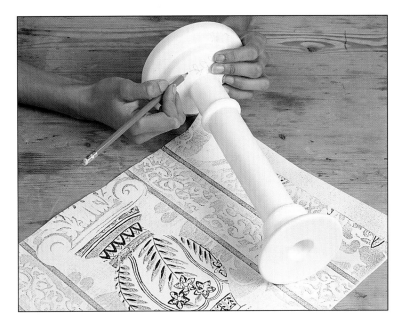

2 Either copy the design straight from the fabric or experiment by enlarging or reducing the part of the design you wish to use on a photocopier. Or, draw a simplified version onto paper. Use a pencil to draw design onto the candlestick.

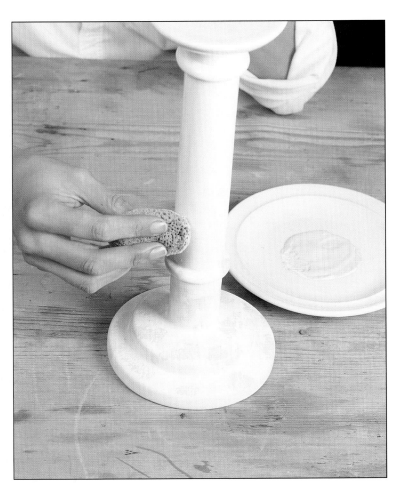

1 Pour the pale yellow paint into a saucer and dip the sponge into it. Remove excess paint on a spare piece of paper. Sponge the yellow paint all over the candlestick. Leave to dry.

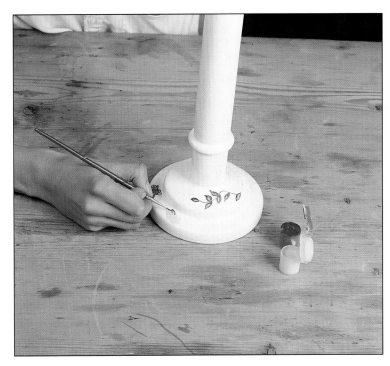

3 Work over the design on the candlestick using a fine paint brush and ceramic paint. Leave to dry before filling in the colour as there will be less risk of smudging.

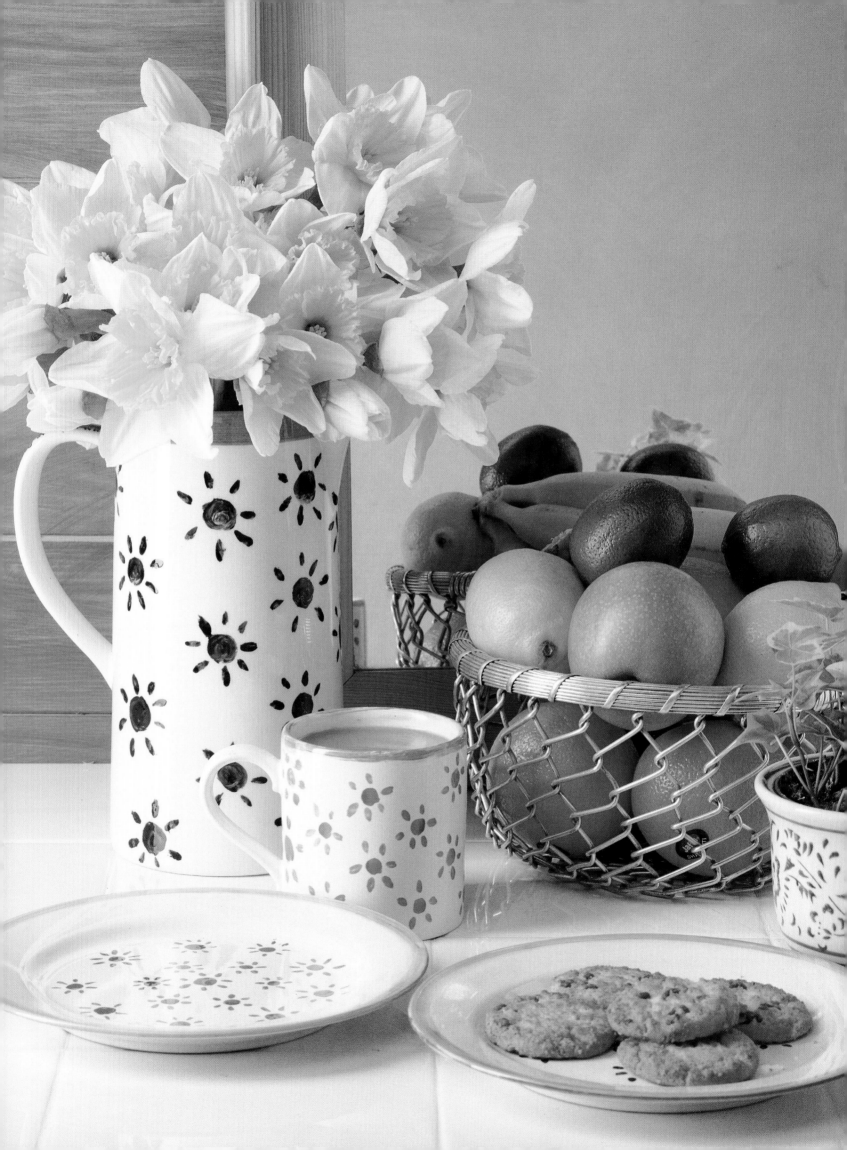

Dots and Dashes Ceramics

This is a simple but effective way of decorating white china. Use the width and length of your paint brush to make straight lines. The jug already had a green band round its top and we decided to add a bit of pattern to it.

Tools and materials

Glass or ceramic paint

White china

Paint brushes

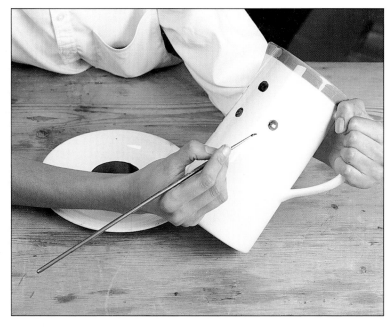

1 Paint circles at even intervals all round the jug.

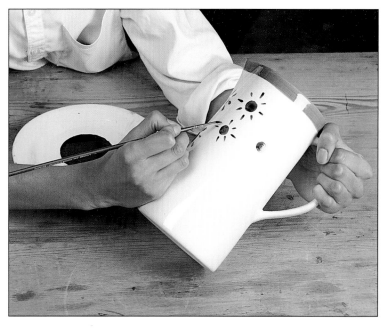

2 Draw lines radiating out from each circle to make stylized flowers.

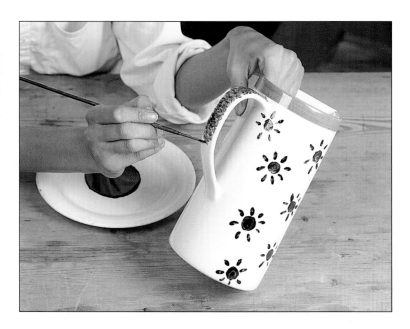

3 Decorate the handle with green stripes painted close together so that they form a band of colour rather like the band round the top of the jug.

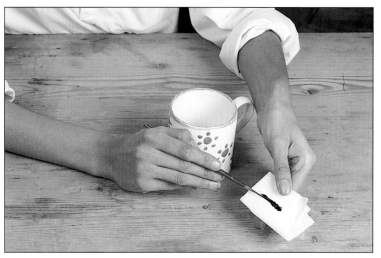

4 Decorate plates and mugs in the same manner, using lines and circles to form different kinds of patterns. Complete the designs by applying paint to tissue paper and gently wiping the edges of the mugs and plates to create a border.

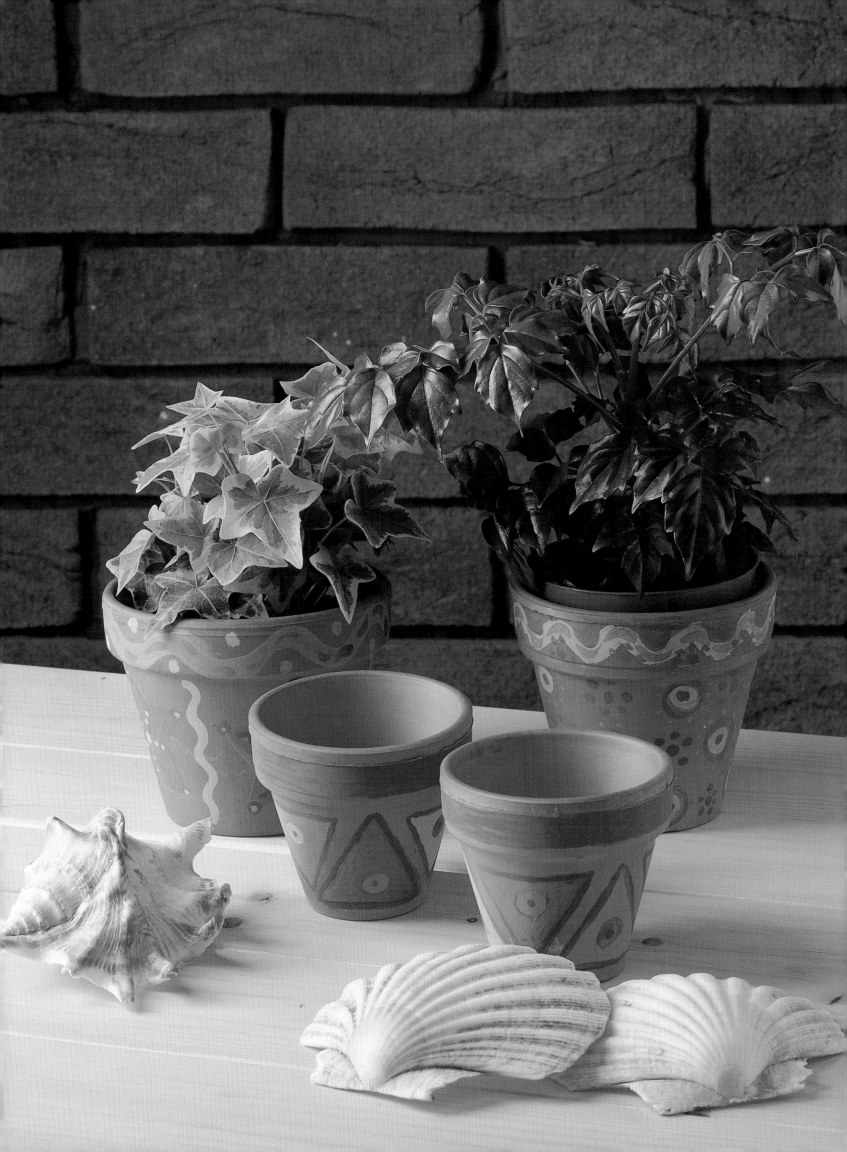

Painted Flower Pots

As a change from plain terracotta, why not paint your flower pots in bright colours to make them more cheerful and interesting and to give them a Mediterranean feel. To prepare old terracotta pots, you should first check for mould and then clean them out using warm soapy water.

Tools and materials

Terracotta pots

Designer's gouache, acrylic, or

Emulsion paint for indoor pots

Paint brush, pencil and paper, felt tip pens

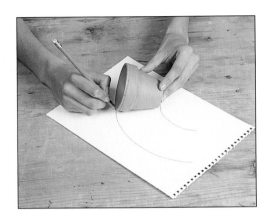

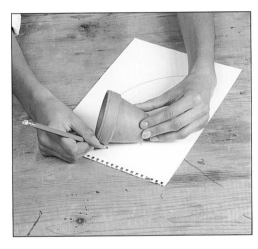

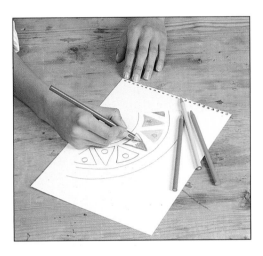

1 *Plan the design on paper making a mark on the top edge of the pot. Then, starting at the mark, lay the pot on a piece of paper and hold a pencil along the top edge. Roll the pot across the paper until you reach the mark again. Repeat for the base edge.*

2 *Measure the depth of the pot rim. Remove this rim area from your template. This will leave your design area.*

3 *Work out the design on the paper pattern. Colour in the design using crayons.*

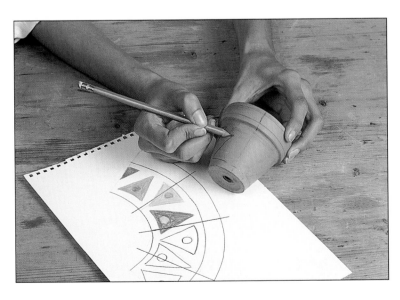

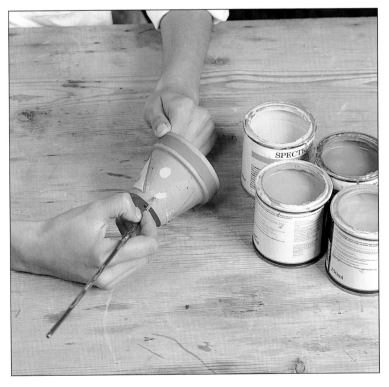

4 *Divide the pattern into quarters and the pot into quarters and transfer the design, a little at a time, using a pencil.*

5 *Paint in your patterns using one colour at a time. Leave to dry between colours to avoid smudging.*

Marbled Tiles

One of the simplest ways of decorating tiles. If they are likely to be subjected to hard wear and tear, protect them with a coat of clear varnish.

Tools and materials

Oil-based glass or ceramic paints

Plastic tray for holding water

Tiles, rubber gloves

Plenty of paper on which to place the tiles

Old paint brush

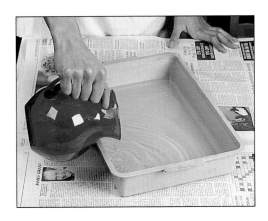

1 *Fill the tray with water. It must be big enough to hold a tile and not too deep.*

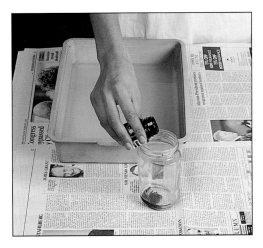

2 *Mix the paint with a little white spirit. This will help the colour to spread over the surface of the water.*

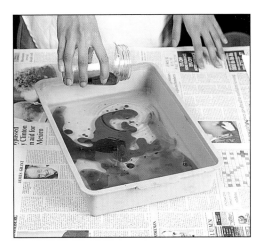

3 *Pour the mixture onto the water and mix the colour with the back of a paint brush.*

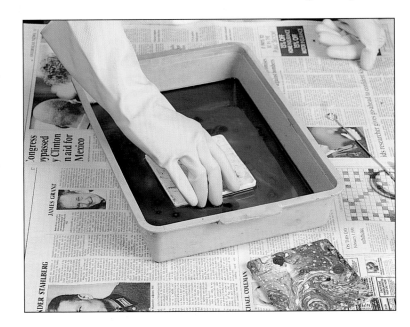

4 *Put on rubber gloves and carefully hold the tile with the glazed side against the surface of the water. The tile will pick up the swirled pattern and give a marbled effect.*

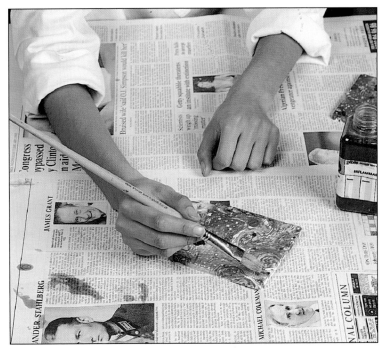

5 *Leave the tiles to dry and then give them a final coat of clear varnish.*

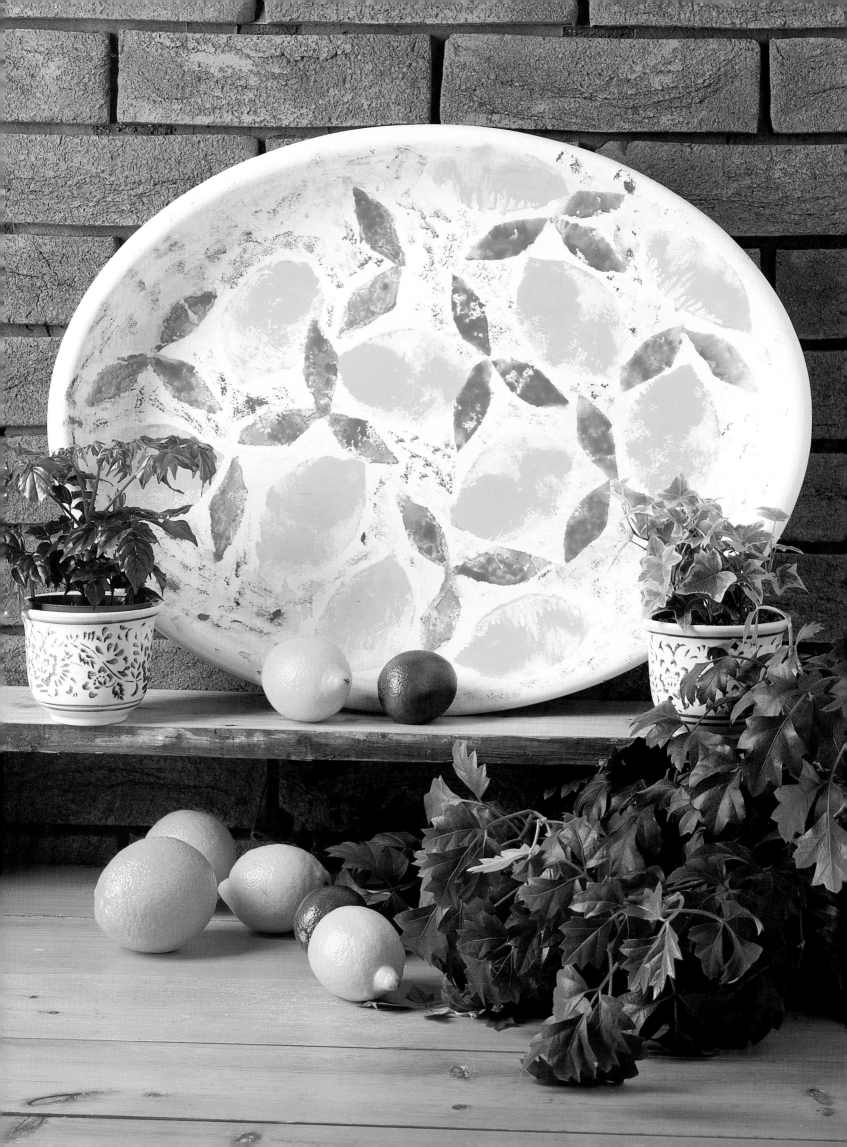

Lemon Plate

This attractive plate is decorated by cutting a sponge into shapes and using them to apply ceramic paint to it. The design can then be built up using other shapes and colours.

Tools and materials

Thin plastic sponge, large plain plate
Small pieces of natural sponge
Ceramic paint, turpentine substitute

1 Draw out your design on paper.

2 Cut the plastic sponge into leaf and lemon shapes.

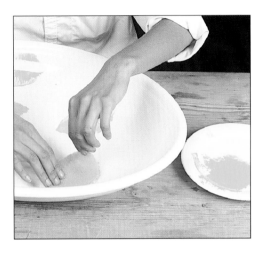

3 Soak the sponge pieces with turpentine and squeeze out the excess. Dip the lemon-shaped sponge in paint and remove excess by dabbing on paper before applying to the dish.

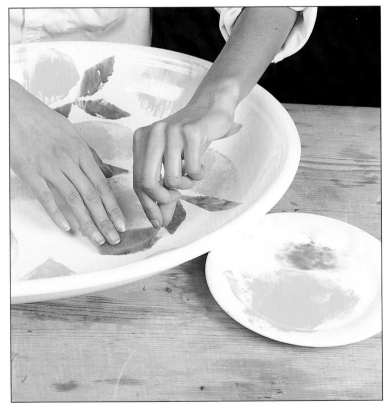

4 Repeat the process with the green leaf shape.

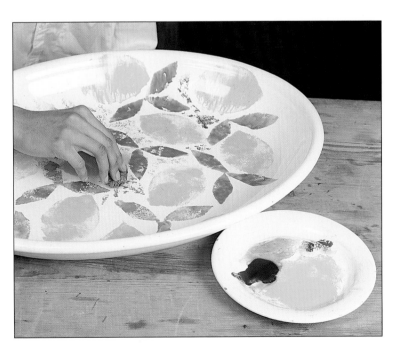

5 Add background patterns using small pieces of natural sponge.

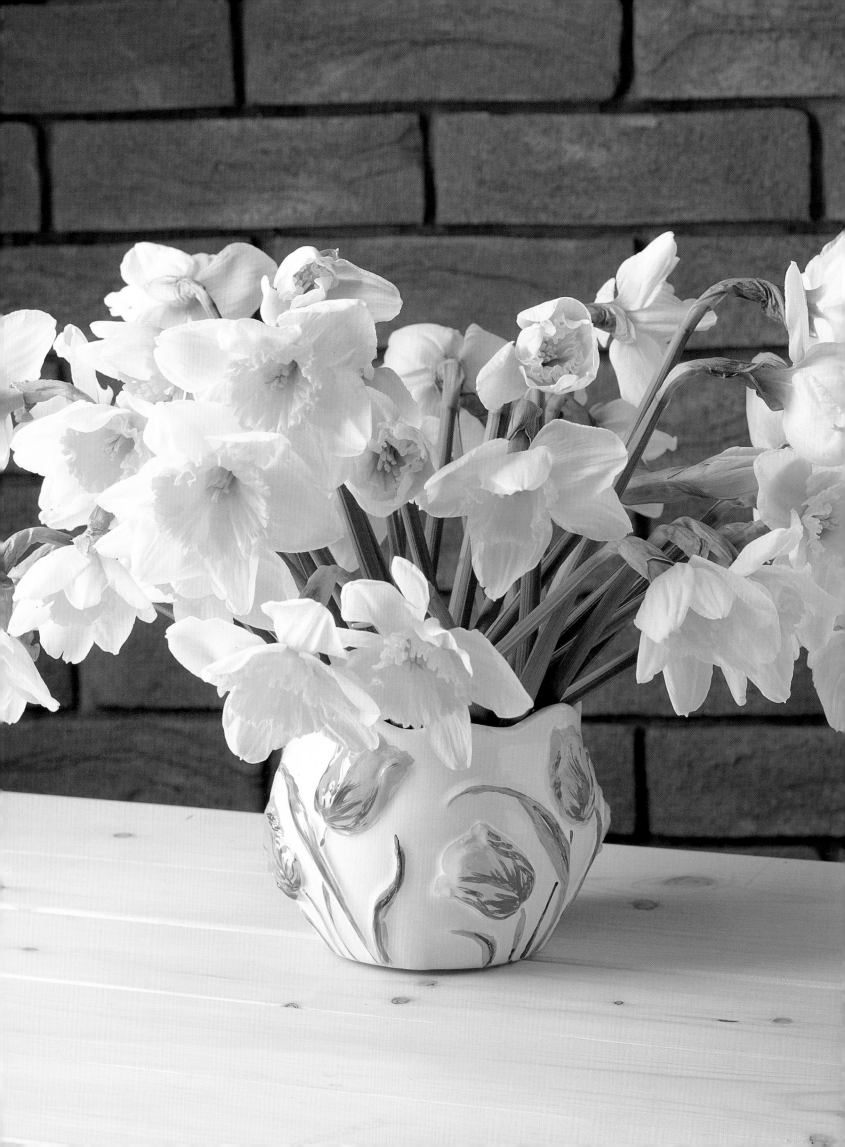

Tulip Vase

Nowadays, you can buy a variety of white china with a raised surface design. The vase shown in this project came from a well known chain of supermarkets. The paints are a mixture of glass and ceramic paints and the result is a pleasing mixture of translucent and opaque colours.

Tools and materials
White china vase with a raised surface design
Glass and ceramic paints, different sized brushes
Turpentine, source book for colour reference (optional)

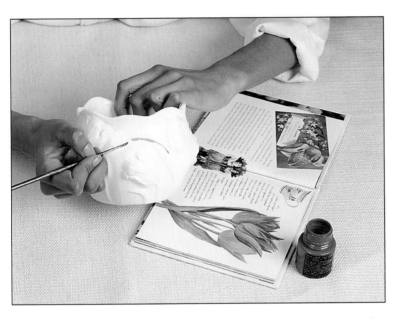

1 *Paint a fine line of green ceramic paint onto the stems and some of the leaves following the lines of the raised pattern.*

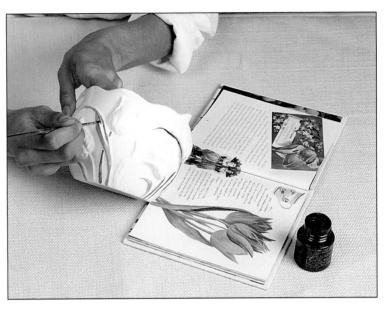

2 *Paint the rest of the leaves using green glass paint. The glass paint may overlap the ceramic paint here and there to blend in the shades.*

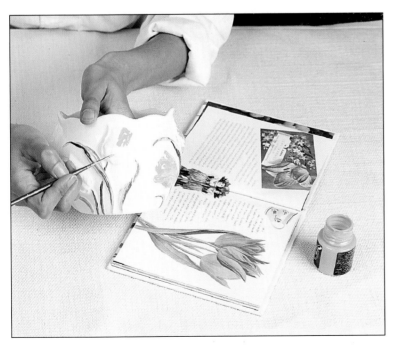

3 *Paint the flower head of each tulip in the colour of your choice, we used yellow.*

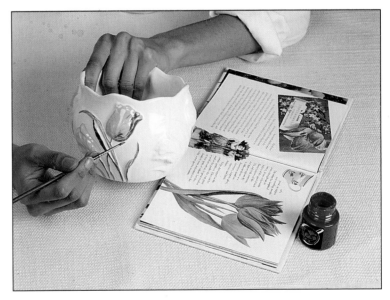

4 *Paint in the fine details on each tulip using a very fine paint brush and a complementary colour, such as red, for the shading. As an extra option, dot a pattern round the top edge of the vase.*

23

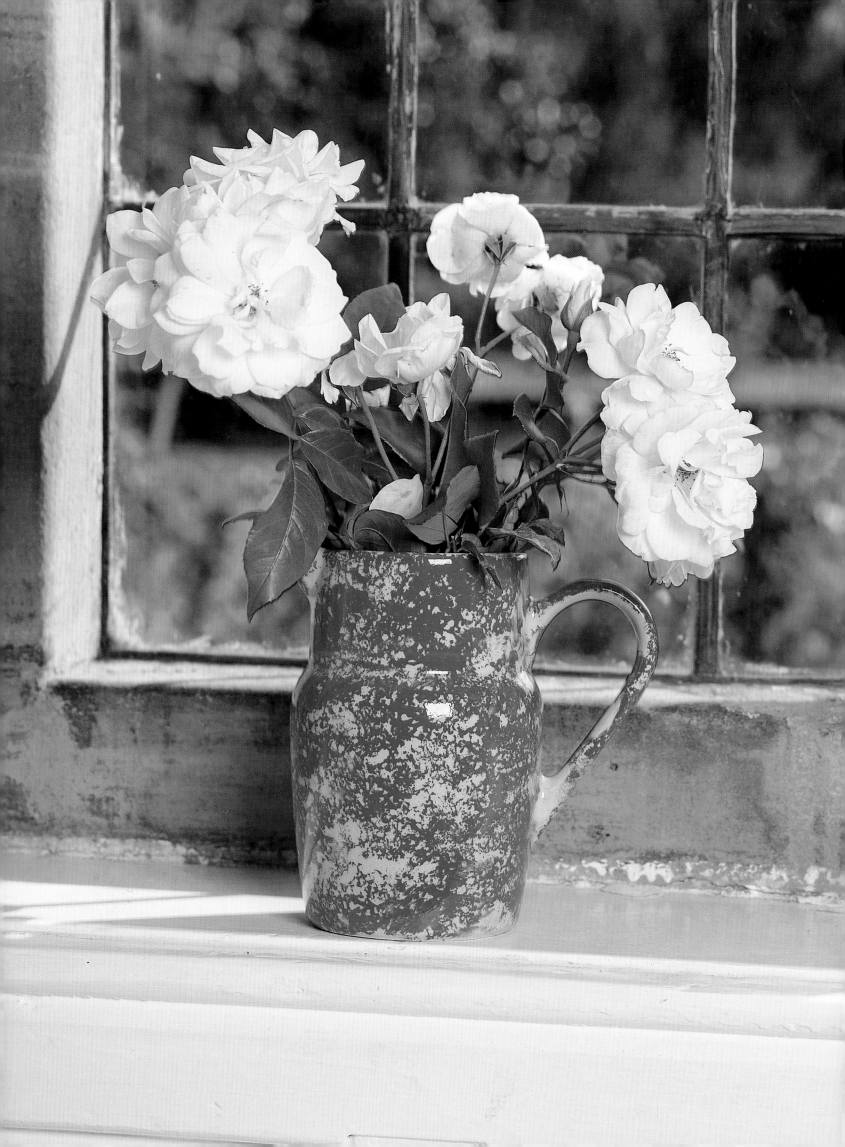

Sponged Ceramic Jug

This painted jug can be used for flowers or as a decorative object in its own right. However, although ceramic paints are suitable for decorating objects such as vases, decorative or commemorative plates, they are unsuitable for use on ceramics which will be used for food and drink.

Tools and materials

Plain white jug,

Sponge, pair of scissors

Ceramic paints

Saucer, newspaper

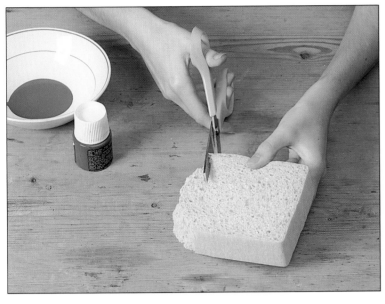

1 Cut the sponge into a small manageable piece. Pour the ceramic paint into a saucer.

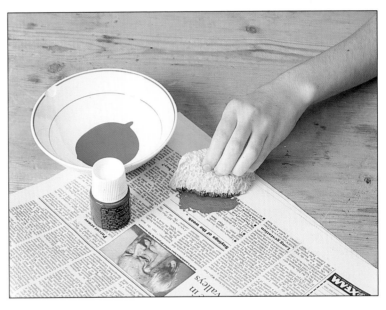

2 Dip the sponge into the ceramic paint and dab it off onto the newspaper to remove excess. Too much paint will result in a blurred pattern.

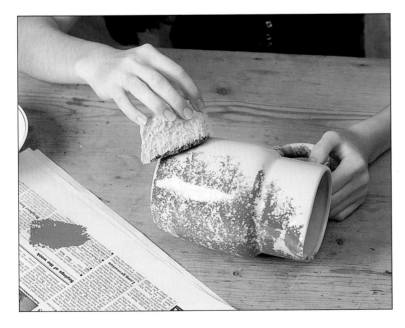

3 Hold the jug firmly in one hand and the sponge in the other. Dab the sponge at random all the way round the jug. Leave to dry.

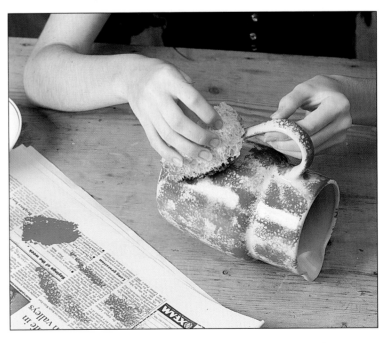

4 Hold the body of the jug and dab the paint onto the handle. Leave to dry.

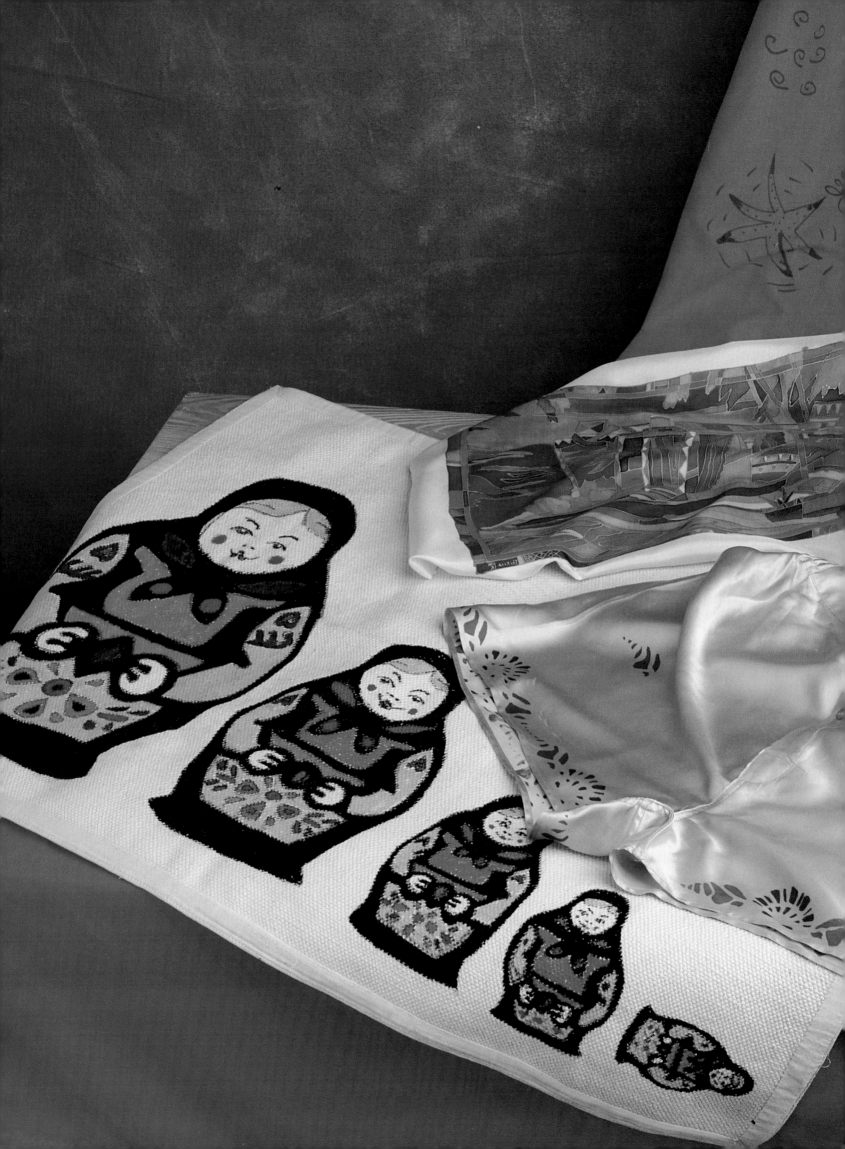

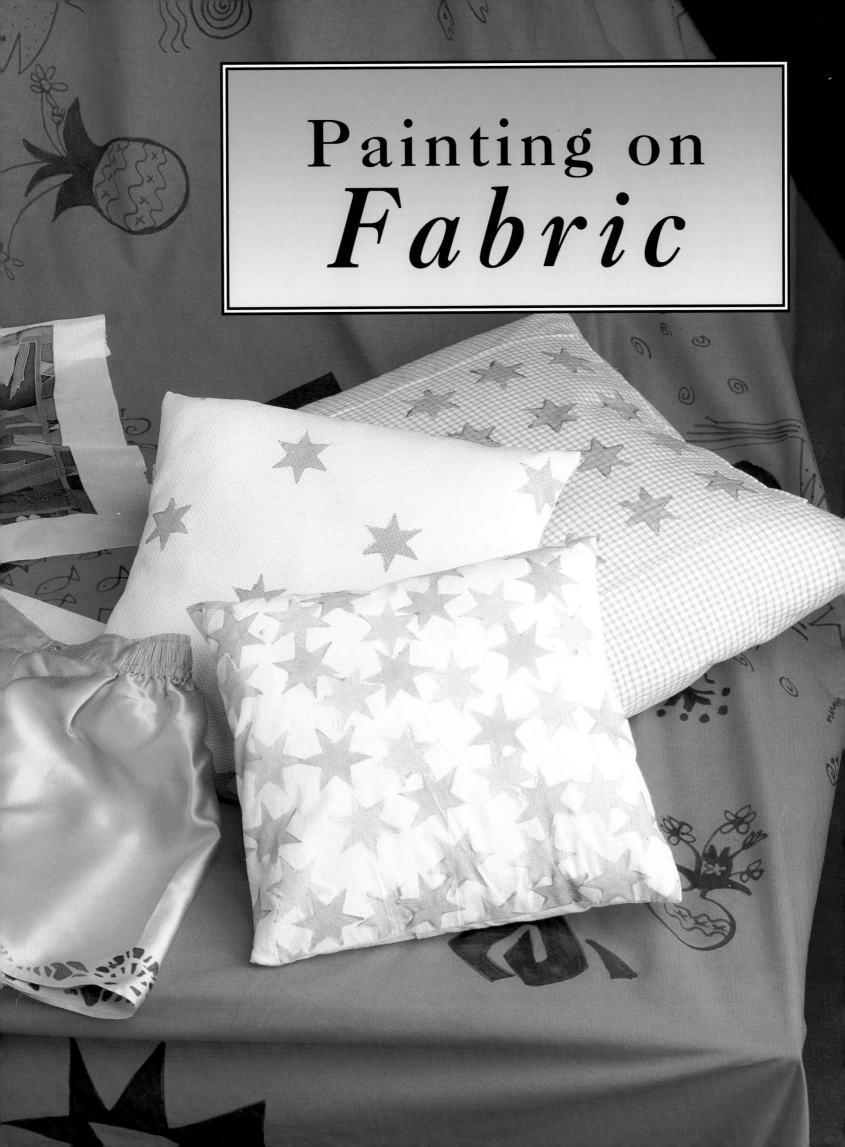

Painting on
Fabric

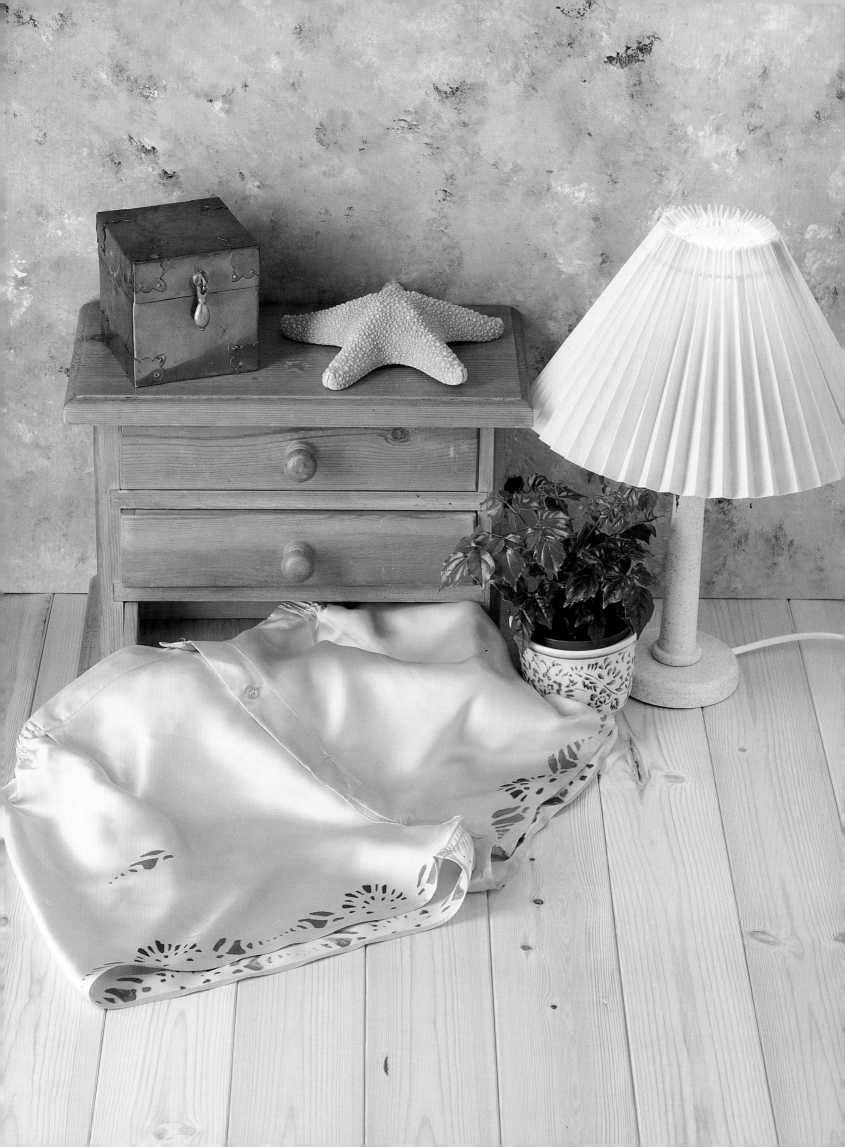

Stencilled Boxer Shorts

Stencilling looks just as effective on a contrasting background as it does on plain white. Here, we have decorated a pink pair of men's boxer shorts using a sea shell stencil and fabric pens in turquoise and blue.

Tools and materials

Silk boxer shorts, vanishing textile marker

Fabric pens, paper and pencil, waterproof marker

Craft knife and cutting mat, clear acetate

1 *Draw your design onto paper or trace off the one in the back of the book. Reduce or enlarge the dimensions as desired.*

2 *Place the clear acetate over the drawing and trace the design using a black marker pen.*

3 *Place the traced design onto the cutting mat and, using a sharp craft knife, cut out the design.*

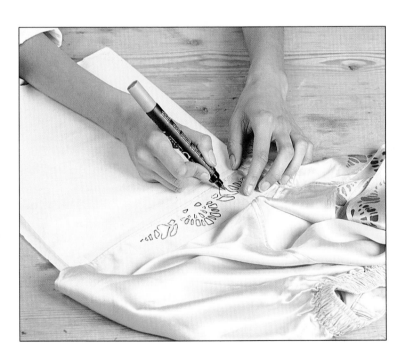

4 *Place paper between the front and back layers of the boxer shorts and position the stencil along the edges. Apply colour through stencil using the fabric felt tip pens. Use turquoise for the smaller shells.*

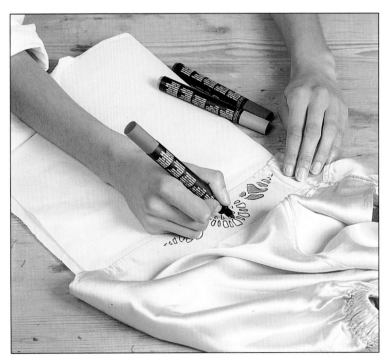

5 *For the larger shells, use royal blue and purple. Turn the shorts inside out and iron on the inside to fix the design.*

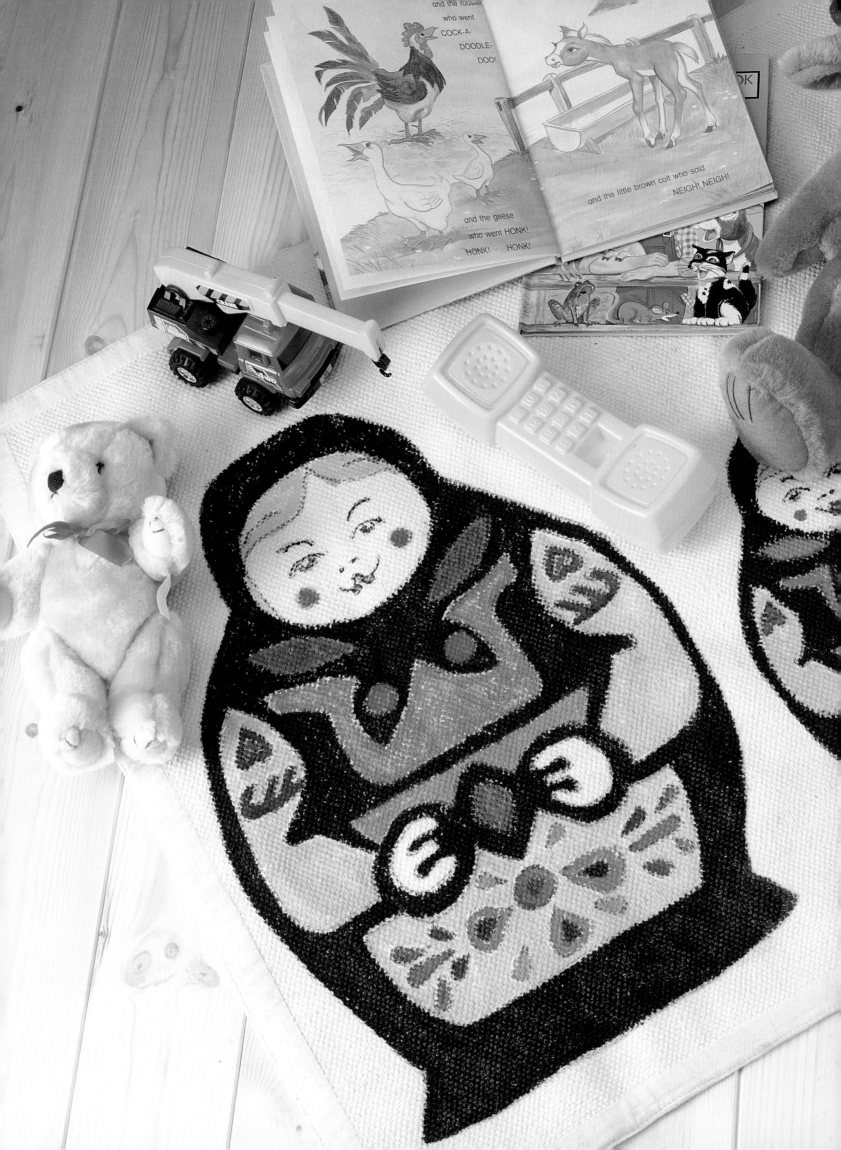

Russian Doll Play Mat

This Russian Doll play mat would make a welcome accessory for any child's room. If you cannot find a light-coloured mat on which to work, cut out one piece of canvas 50cm x 90cm (20ins x 35ins). Cut another piece, 1cm larger all the way round for the top layer.

1 *Trace the template of the baboushka from the back of the book and enlarge it on a photocopier. Then, enlarge the next image and the next, until you have five images each one slightly larger than the next.*

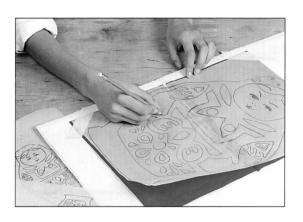

2 *Place a piece of carbon paper under the largest template and on top of the rug. Trace over the design and it will be transferred to the rug below. Repeat this process with the other images so that you now have a row of dolls in graduated sizes.*

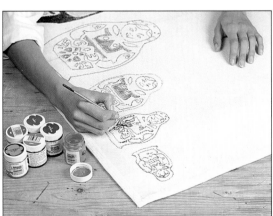

3 *Using various coloured fabric paints and different size brushes, paint the main colours of the design onto the rug. Use large brushes for large areas.*

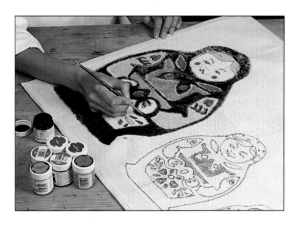

4 *Using a small brush, add the details. Leave to dry. If making a new mat, sew the top to the bottom mat, and turn under the edges of the larger onto the smaller to neaten. Use a large needle and simple stitches along the edge of the mat for a decorative finish.*

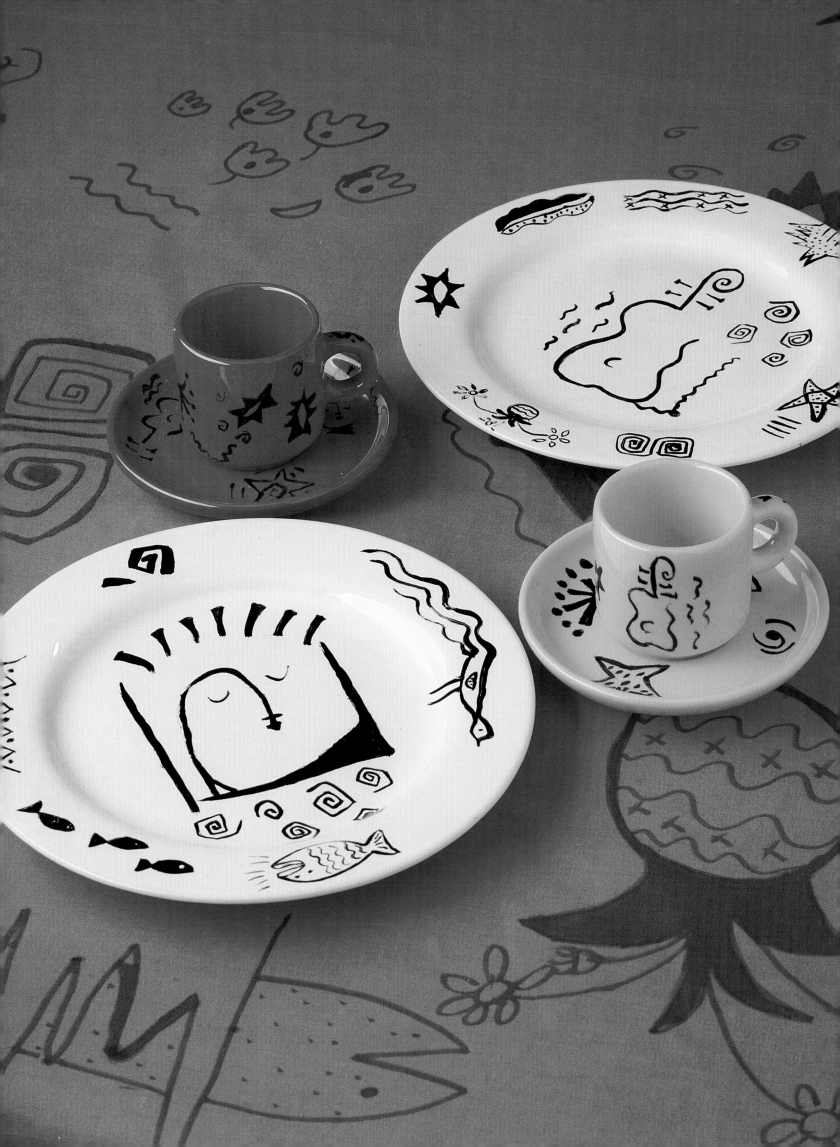

Homage to Picasso Tablecloth

Stylized women, musical instruments, fish, leaves and abstract patterns are all used to turn a red sheet into a dramatic tablecloth. Look around for suitable inspiration and make a tracing or template. Better still, draw your designs free-hand for an even better effect.

Tools and materials
Poly-cotton sheet or table cloth
Black fabric marking pens
Iron
Black ceramic paint

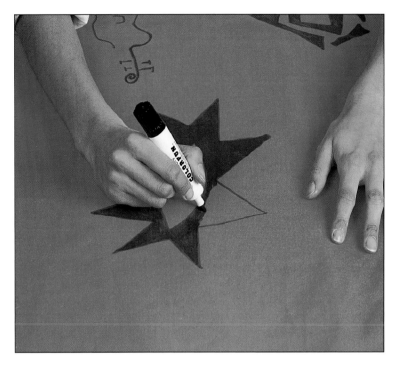

2 *Go over the pencil lines using a black fabric marker. Colour in with more black any areas which need to be more dense. Iron on the back of the cloth to fix.*

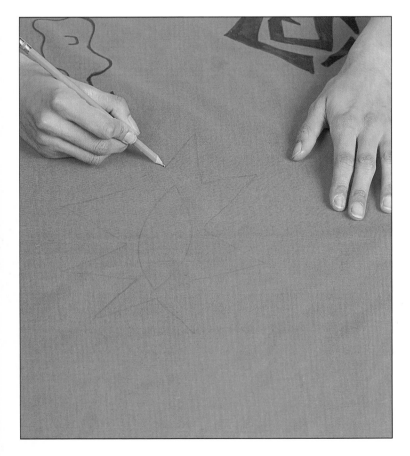

1 *Draw your designs free-hand onto the cloth, using a soft pencil. Or, using a stencil which you have made, tape to the fabric and stamp through with a fabric pen.*

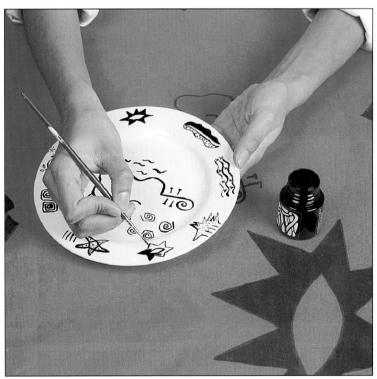

3 *Using ceramic paints, decorate plain china using the same motifs. (See page 8).*

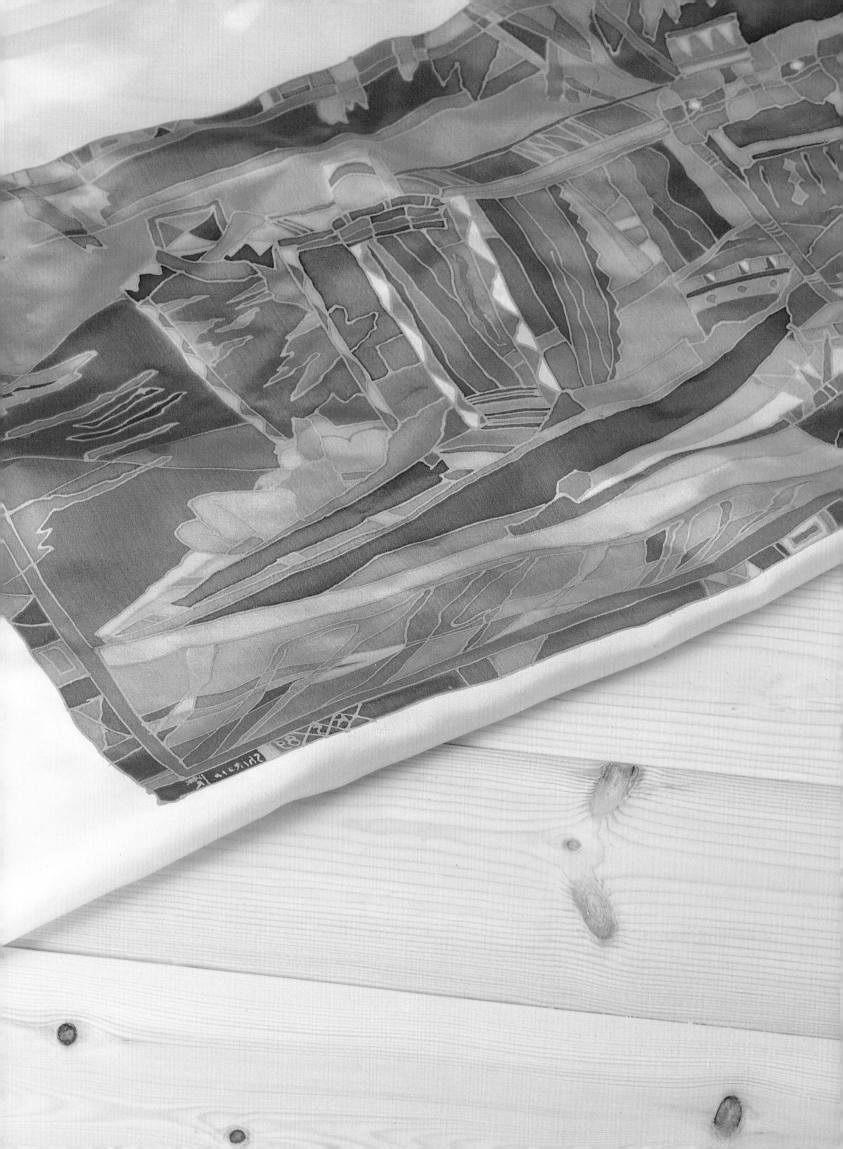

Silk Painted Scarf

Create your own beautiful designs for silk scarves, ties etc. Painting on silk is becoming particularly popular. First, a barrier of gutta is applied, much as the lead in a stained glass window, then the colour is added. The line of the gutta prevents the colour from spreading.

Tools and materials

Heavy-weight habotai silk, iron, wooden silk frame
Three-pronged silk pins, black felt tip pen
Tracing paper, masking tape, vanishing textile marker
Metallic gutta pen, silk paints in a variety of colours
Paper tissue, paint brushes, paper, frame, spray glue

1 *Sketch your design and work out the colours.*

2 *Wash, dry and press the silk. Stretch it onto the wooden frame and hold in position with the pins. The fabric must be absolutely taut with no wrinkles.*

3 *Tape the design onto the underneath of the stretched silk with pieces of masking tape at each corner. Using the vanishing pen, trace off the design.*

4 *Apply the metallic gutta pen to the outline of the design. This will block the mesh of the silk preventing the silk paint from bleeding and merging. Allow gutta to dry thoroughly.*

5 *Arrange all the painting equipment so that it is within easy reach. Apply the silk paints taking care not to splash or go over any lines of gutta. Keep a tissue to hand to mop up any excess paint from your brush.*

6 *Place the painted silk face down between two sheets of clean white paper and iron it according to the manufacturer's instructions on fixing paint.*

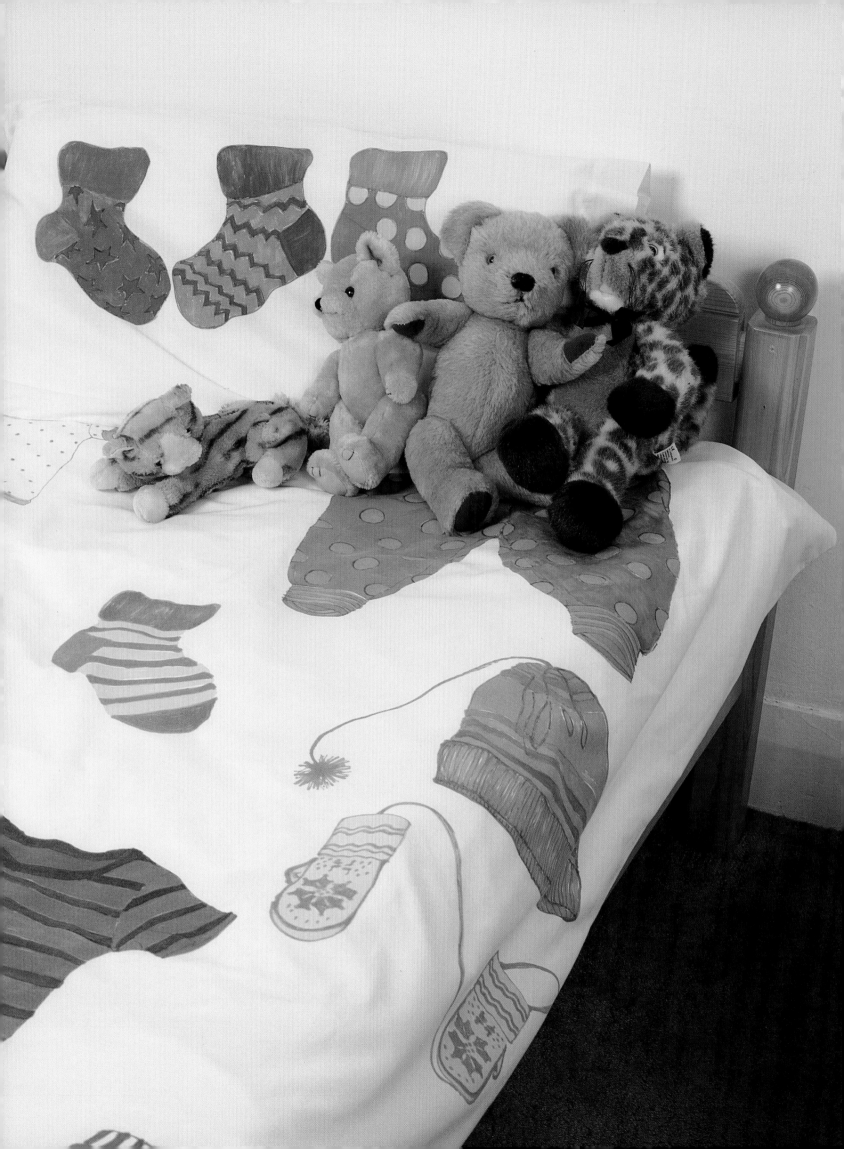

Child's Duvet Cover

Maybe drawing clothes all over a duvet isn't the best way to teach your children how to be tidy – but it is good fun! The fabric pens used here have been developed for ease of use and fixing. You must draw on a white sheet or duvet cover in order to get pure colours.

Tools and materials

White duvet cover or sheet and pillow case
Coloured fabric pens in as many colours as possible
Newsprint or other paper, a large pad of tracing paper
Black felt tip pen, lots of small children's clothes to trace
Masking tape, iron

1 Place a piece of tracing paper over each piece of clothing in turn. Using a thick black pen draw round the outline of the garment onto the tracing paper. The line must be thick so that you can see the design through the sheeting.

2 Arrange and tape the tracing paper designs to the underside of the sheeting. If you are working on a duvet cover, then place some newspaper below the tracing paper in order to prevent seepage of colour from the top to the bottom layer.

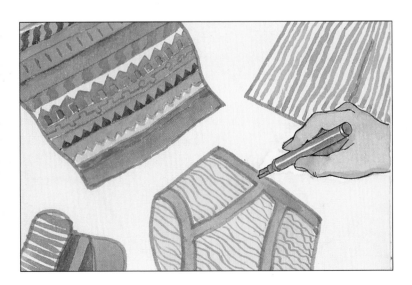

3 Press hard on the fabric so that you can see the shape of the tracing showing through underneath. Outline each of the garments in the appropriate colour.

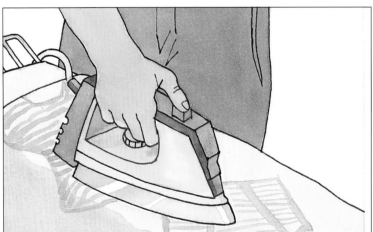

4 Fill in the details of patterns, seams, zips, buttons etc. with other colours. Remove tracing paper. Turn the fabric over and iron the back according to the manufacturer's instructions on fixing.

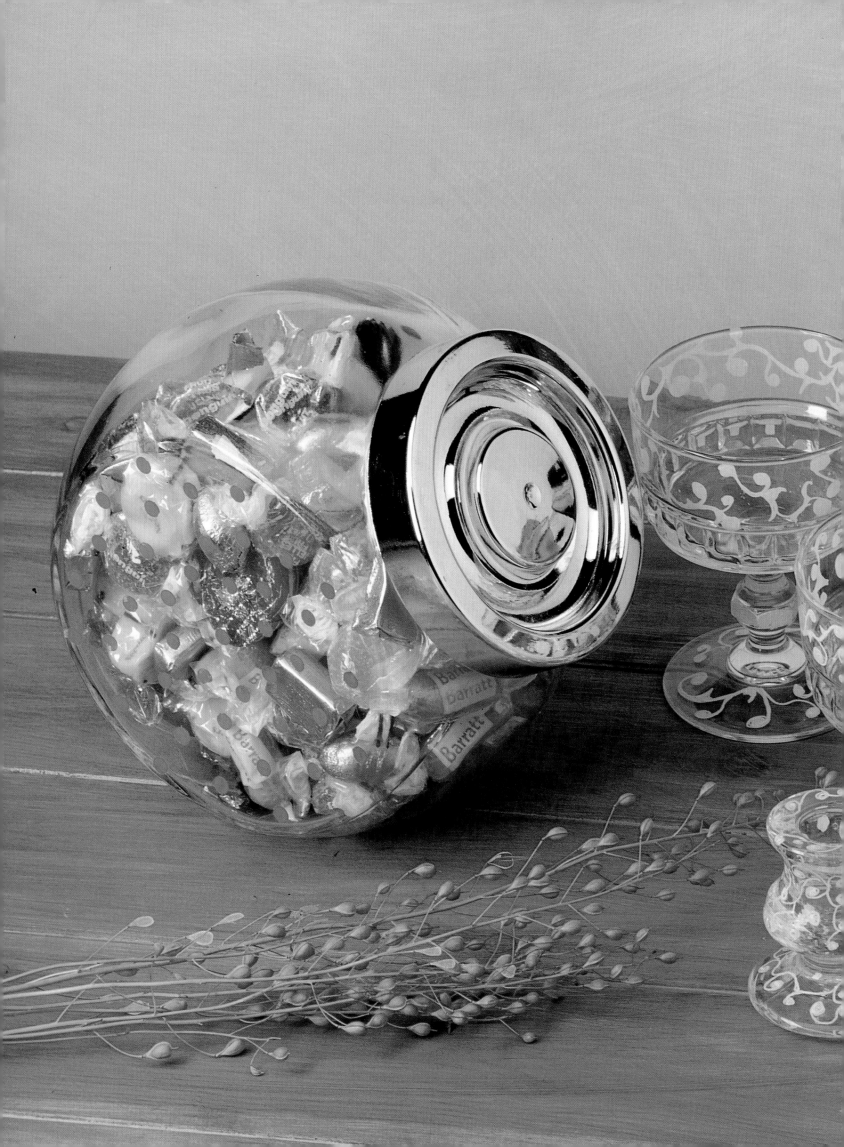

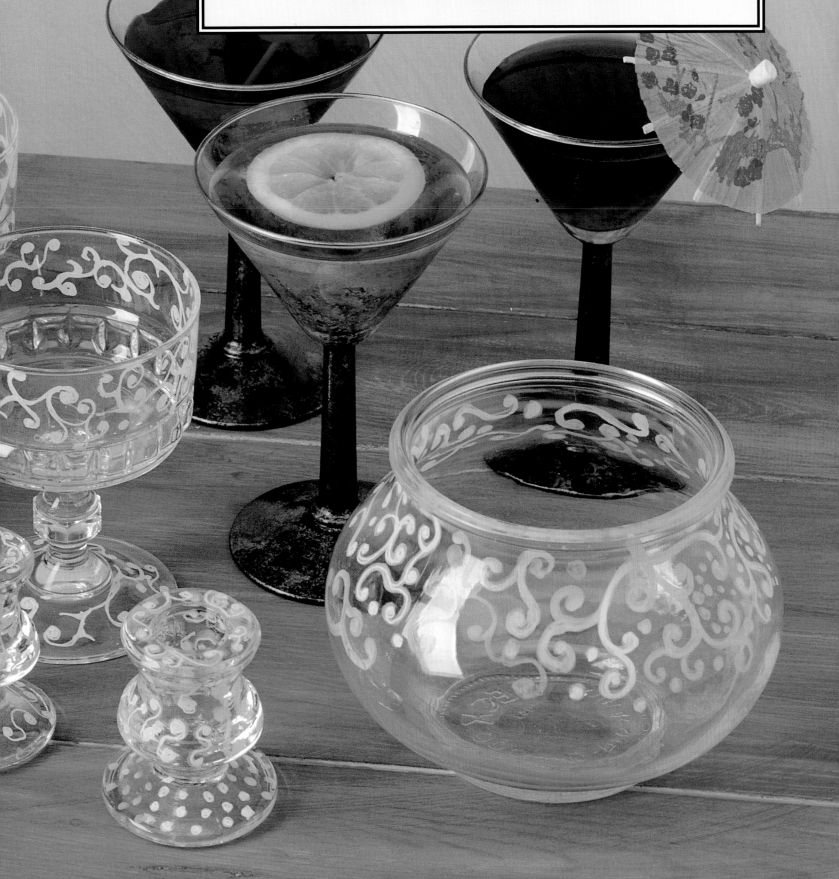

Painting on *Glass*

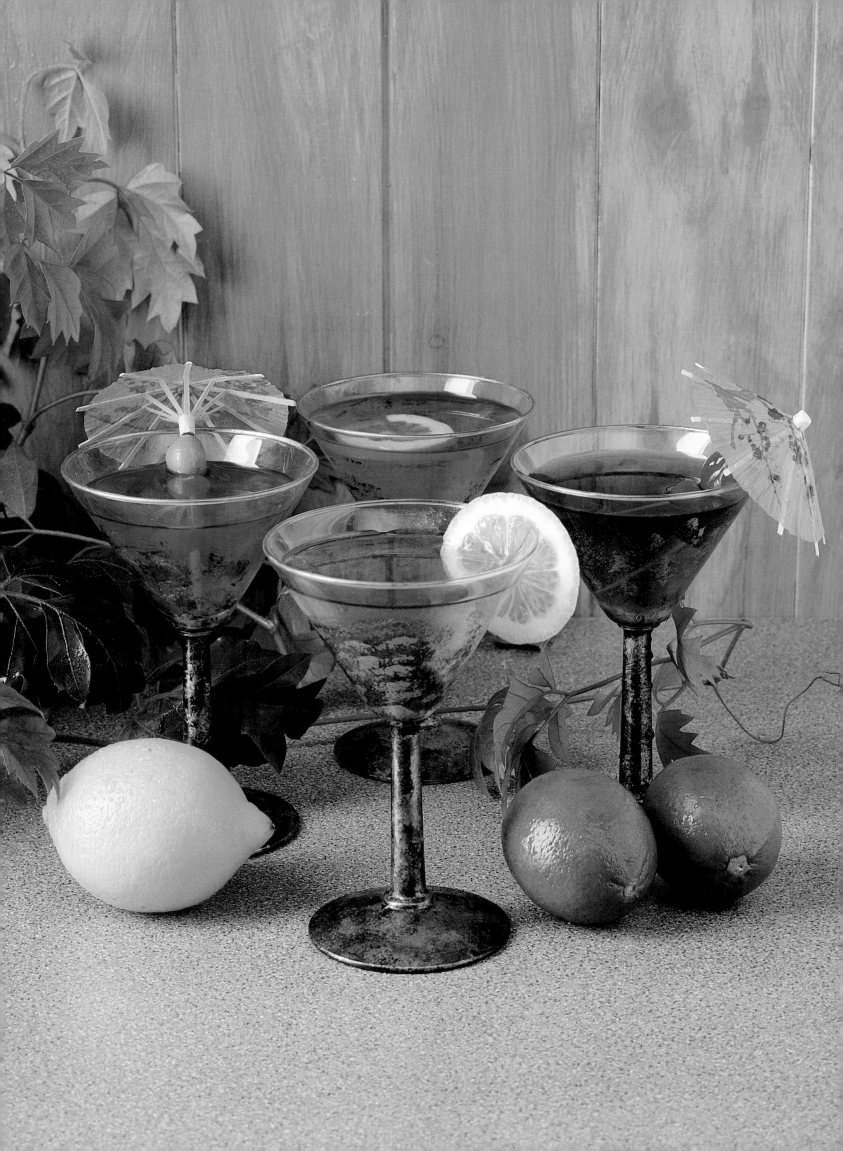

Cocktail Glasses

This is a quick and effective way of decorating some rather plain cocktail glasses using glass and ceramic paints. These paints are meant for decorative purposes only – so do not extend the paint to the edges of the glasses.

Tools and materials
Cocktail glasses
Small natural sponge
Gold ceramic paint
Turquoise glass paint
Paper

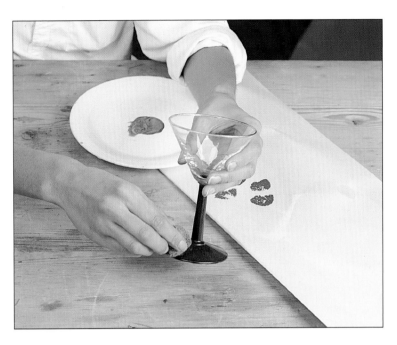

2 *Remove excess paint from sponge by stamping it onto paper. This is so that there is not too much paint which would otherwise make the sponge marks show up on the glass. Sponge gold paint onto the stem and base of the glass. Leave to get tacky for two hours.*

1 *Pour the paint into a saucer and dip the sponge into it.*

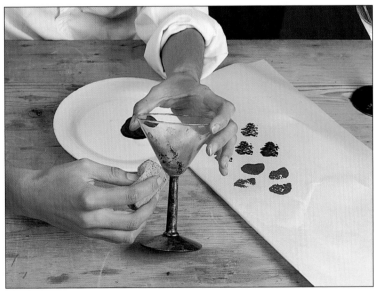

3 *Pour turquoise glass paint into a saucer. Take a second piece of sponge, and dip into the turquoise paint, then sponge off the surplus paint onto paper. Go over some of the parts of the gold with the turquoise. Leave to dry.*

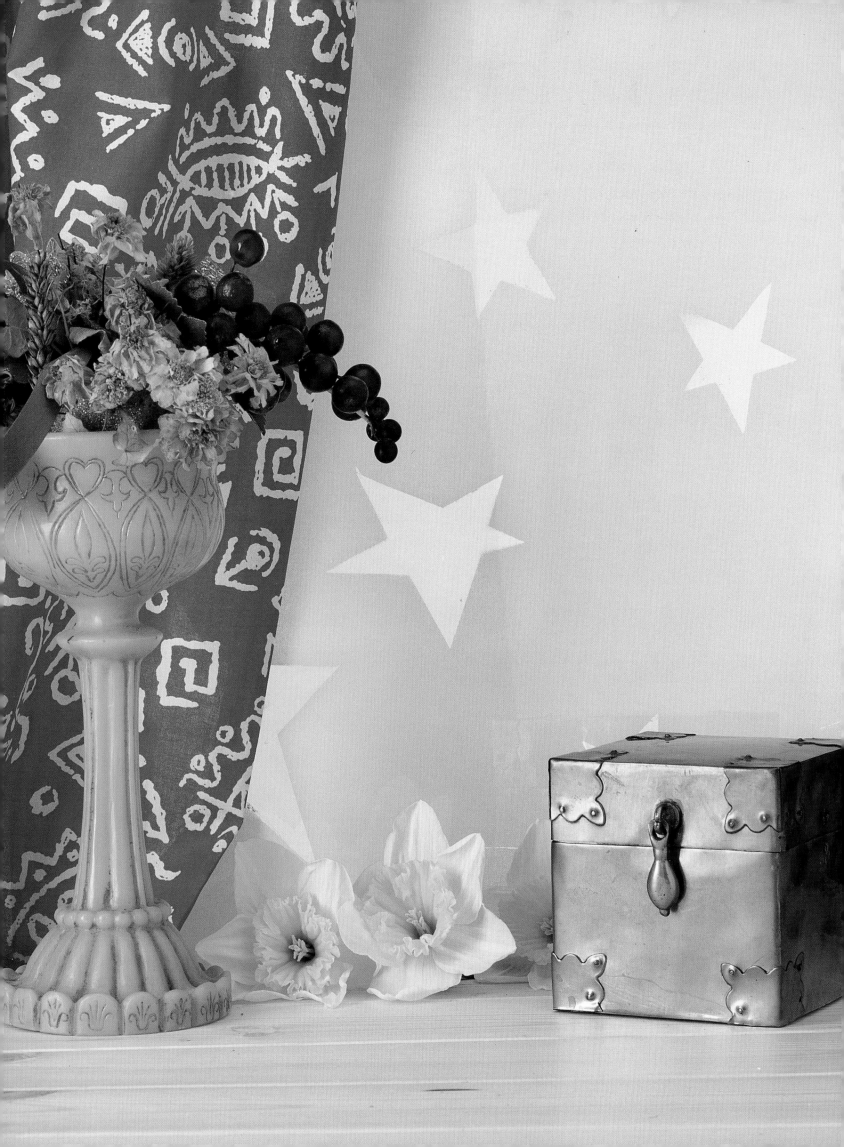

Frosted Glass Effect

This design can be done in either positive or negative form. It is a useful technique for decorating small windows or door panels using white spray paint to create a frosted glass effect on clear glass.

Tools and materials

Tracing paper, pencil, card and spray glue

Stencil brush, white matt spray varnish

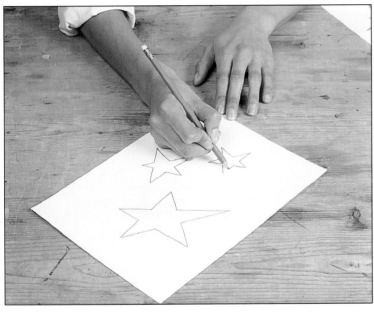

1 *Trace the star designs from the back of the book and trace onto card or thick paper.*

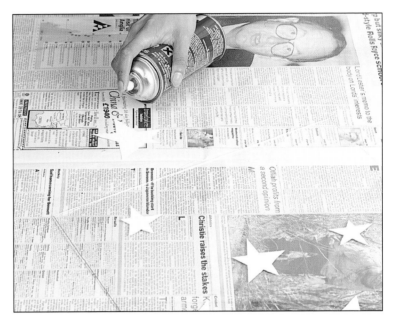

2 *Cut out the motifs, lightly spray the backs with spray glue and arrange all over the glass.*

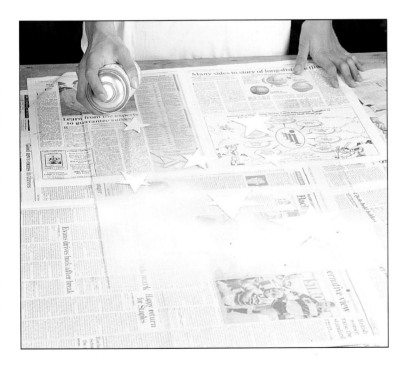

3 *Spray the white varnish all over onto the glass. Leave to dry.*

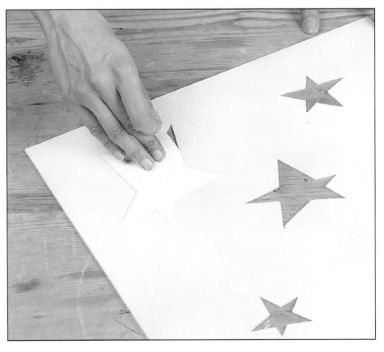

4 *Remove the motifs with tweezers, being careful not to scratch the surface of the glass.*

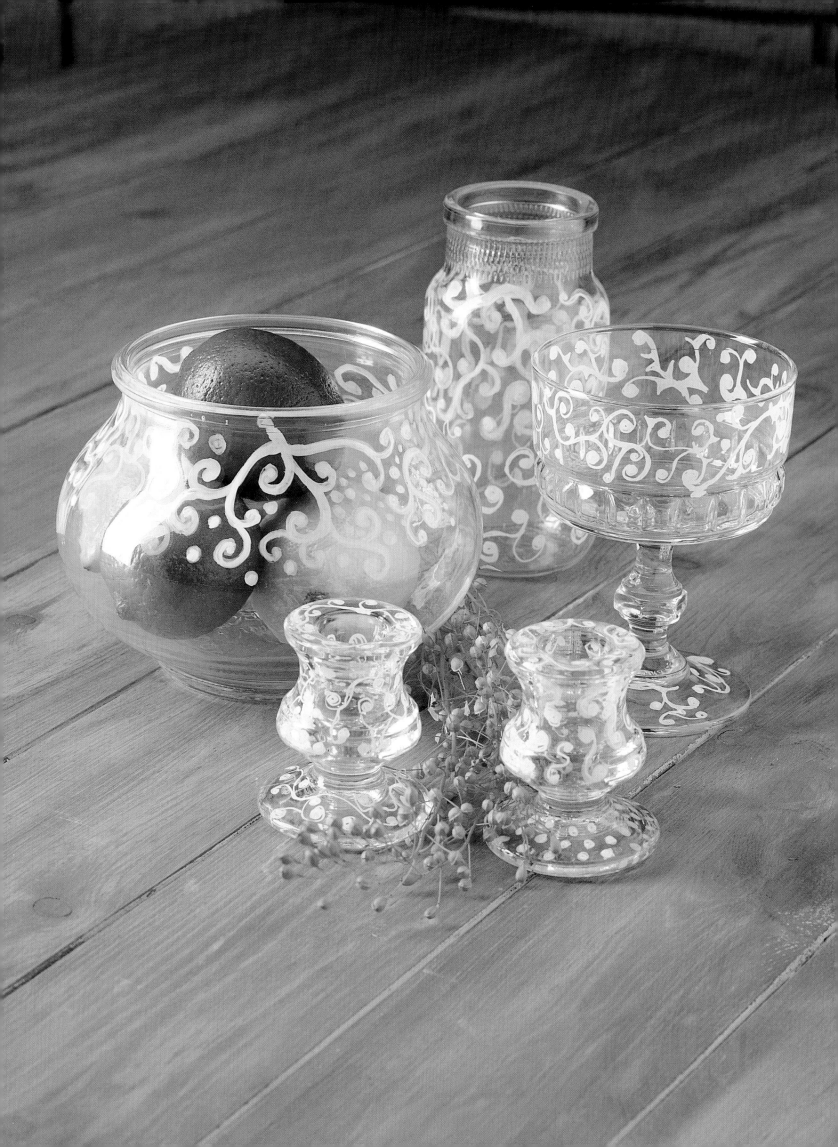

Painted Glass

This is a novel way of decorating plain glass using white ceramic paint and/or white permanent marker. These paints are meant for decorative purposes only so do not extend the paint to the edges of the glasses.

Tools and materials

Plain glass candlesticks, bowl

Sundae glasses, jar

Fine paint brush

White ceramic paint

White permanent marker

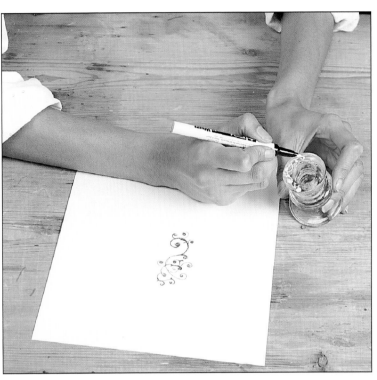

2 *For the small pieces of glassware, use the fineline permanent marker.*

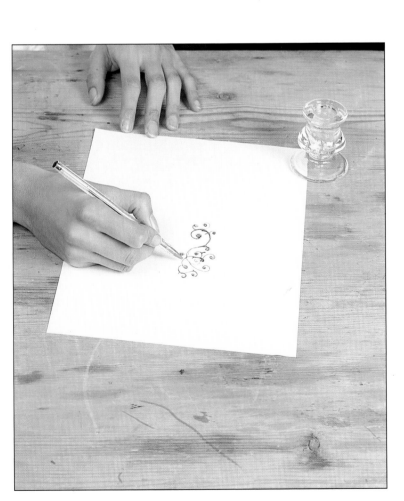

1 *Draw designs out on paper.*

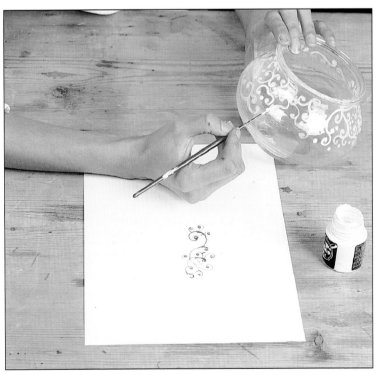

3 *Using the design as a guide, dip the paint brush into the ceramic paint and paint the design all over the jar or bowl.*

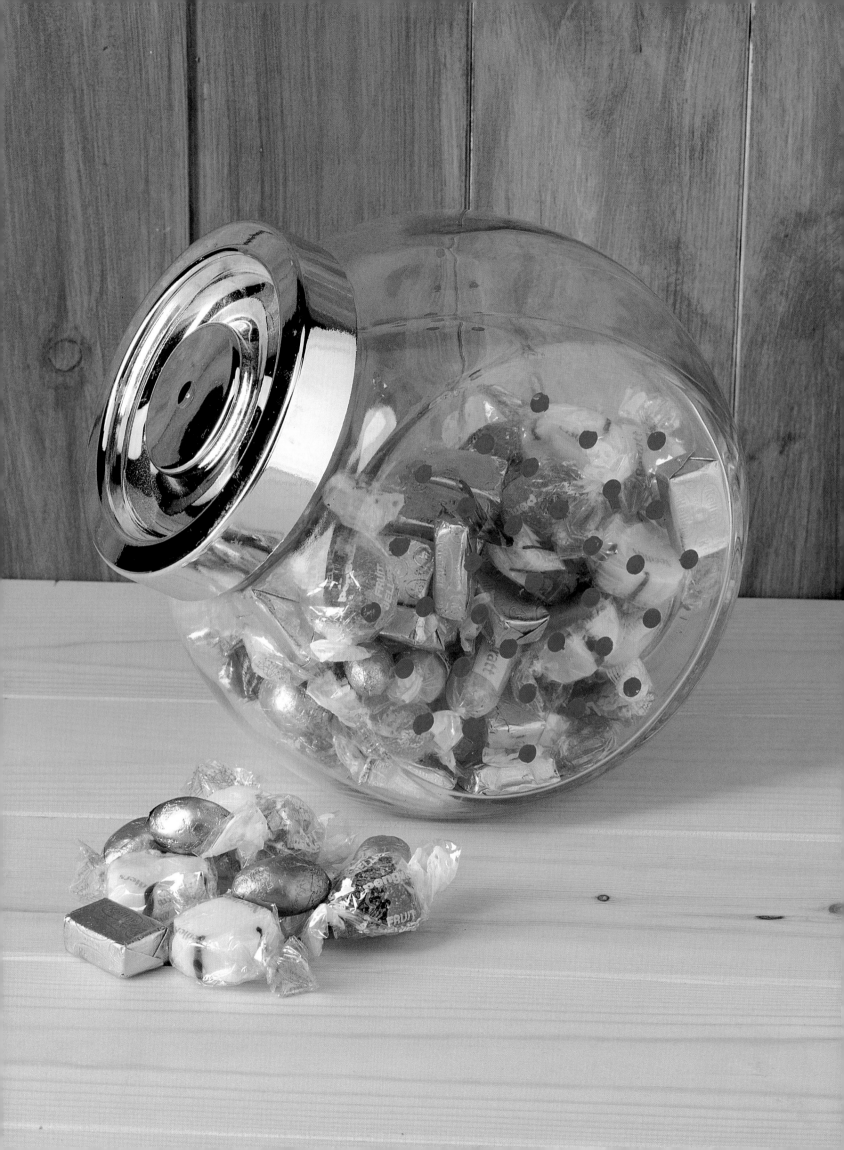

Dotty Sweet Jar

This is an extremely simple method of decorating glass. All you need are ring binder reinforcements, glass paints and a brush. The same technique can be used on storage jars and vases of china and glass.

Tools and materials
Glass jar
Ring binder reinforcements
Small paint brush
Glass and/or ceramic paints

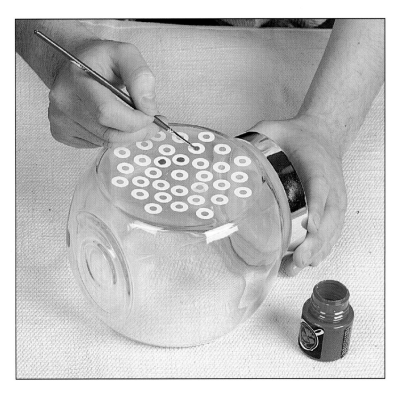

2 *Paint in the centres of the reinforcements, changing the colour on the other side of the jar.*

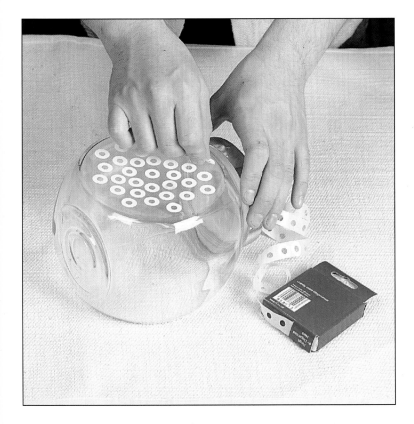

1 *Take the ring reinforcements off their backing paper and stick them onto the jar in a spiral pattern or however you wish to arrange them.*

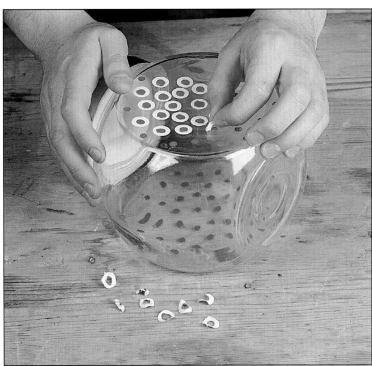

3 *Leave to dry then peel off the reinforcements, leaving perfect dots underneath.*

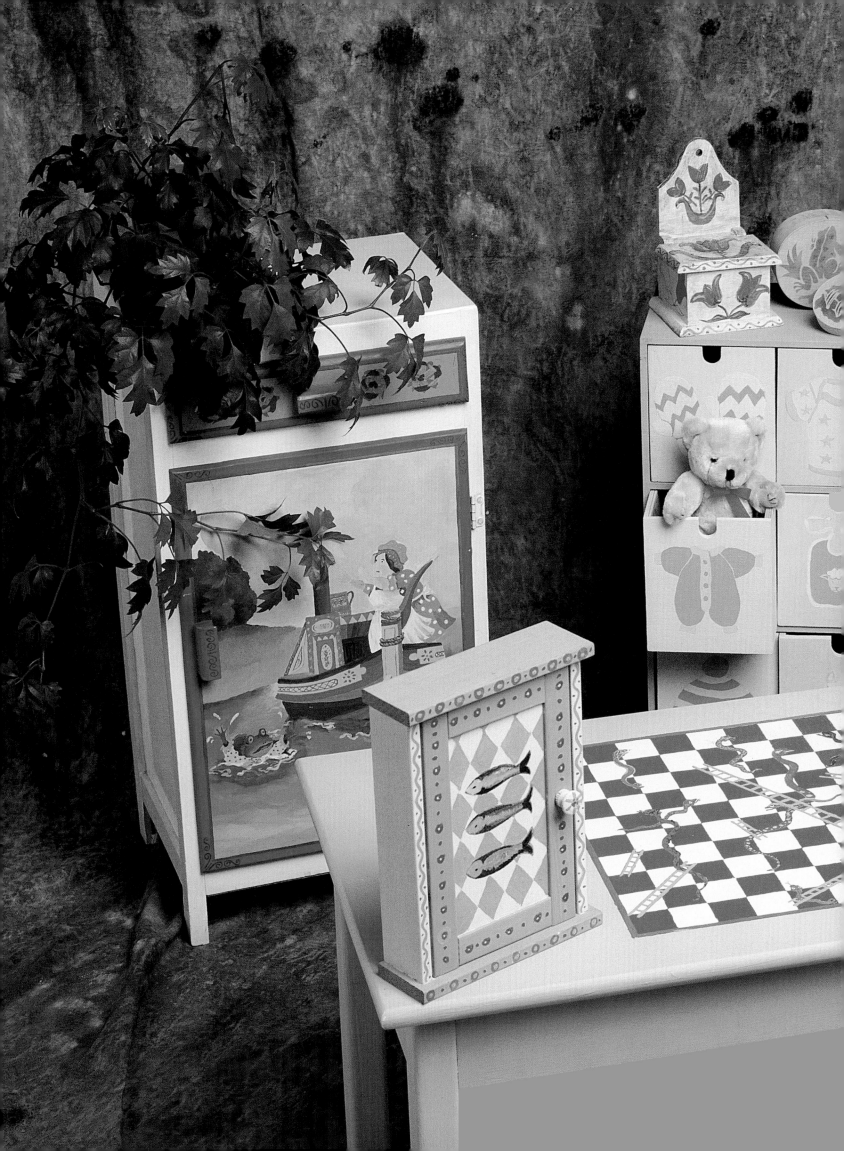

Painting on
Wood

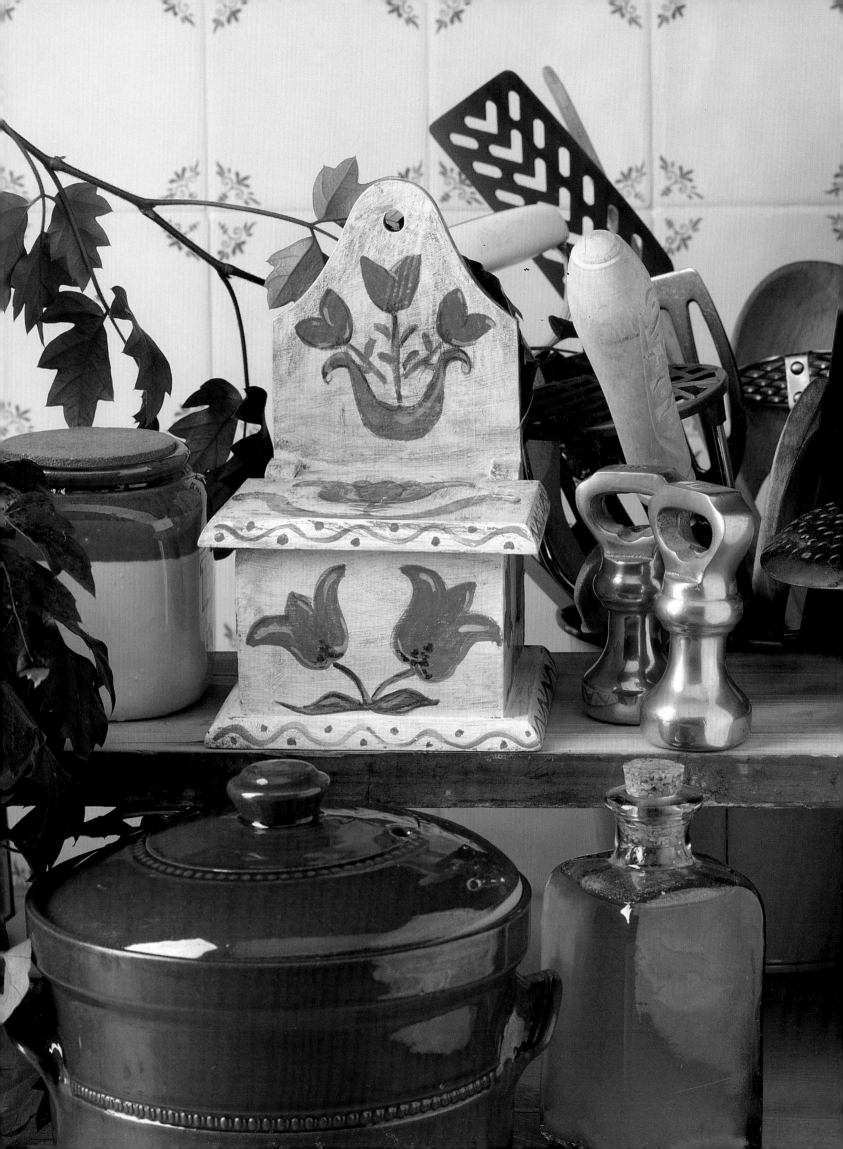

Salt Box

Choose a simple ethnic or folk design in keeping with this homely object. Early American folk art designs in bright bold colours and simple motifs look good. Your design could be a simple stylized tulip or something slightly more complex. The motif can be applied to the front of the box or it can be continued all the way round.

Tools and materials

Emulsion paint for the background colour

Acrylic paints, pencil

Fine sandpaper, artist's brush, box to paint

Shoe polish and a duster

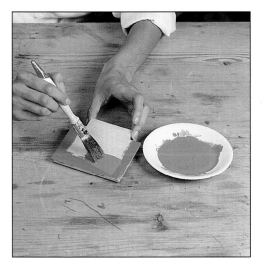

1 *Paint the box with a mid-blue base coat of emulsion paint. Leave to dry.*

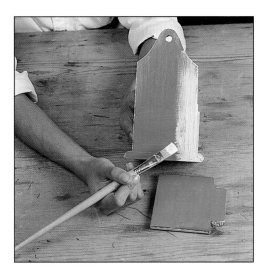

2 *Paint a top coat of emulsion in pale yellow. Leave to dry.*

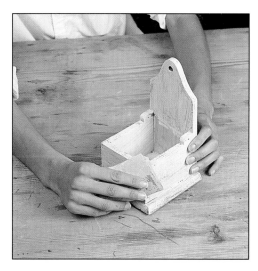

3 *Sand with fine grade sandpaper so that the colour beneath is revealed here and there.*

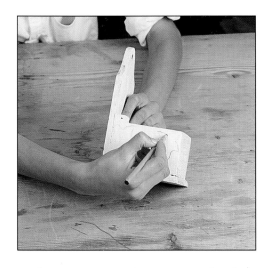

4 *Draw the design on the box using pencil. If you make a mistake you can always rub it out with a pencil eraser.*

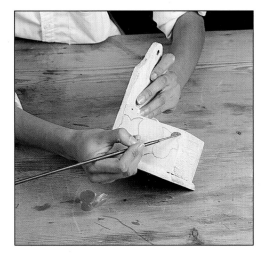

5 *Paint in your design over the pencil lines. Remember you can always dilute the paint and begin the design faintly, adding depth of colour as you work.*

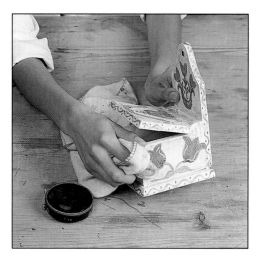

6 *When the colour is dry, rub in a small amount of brown shoe polish using a soft duster.*

Snakes and Ladders Table

A pine coffee table is transformed into a child's table by giving it a coat of satin wood paint and decorating it with a game of snakes and ladders. This not only performs a useful play function but also adds an interesting decorative touch as well.

Tools and materials
Pine coffee table, sandpaper, undercoat, primer
Satin finish paint, decorator's paint brush
Artists' paint brushes, carbon paper, tracing paper
Pencil, transfer numbers, masking tape

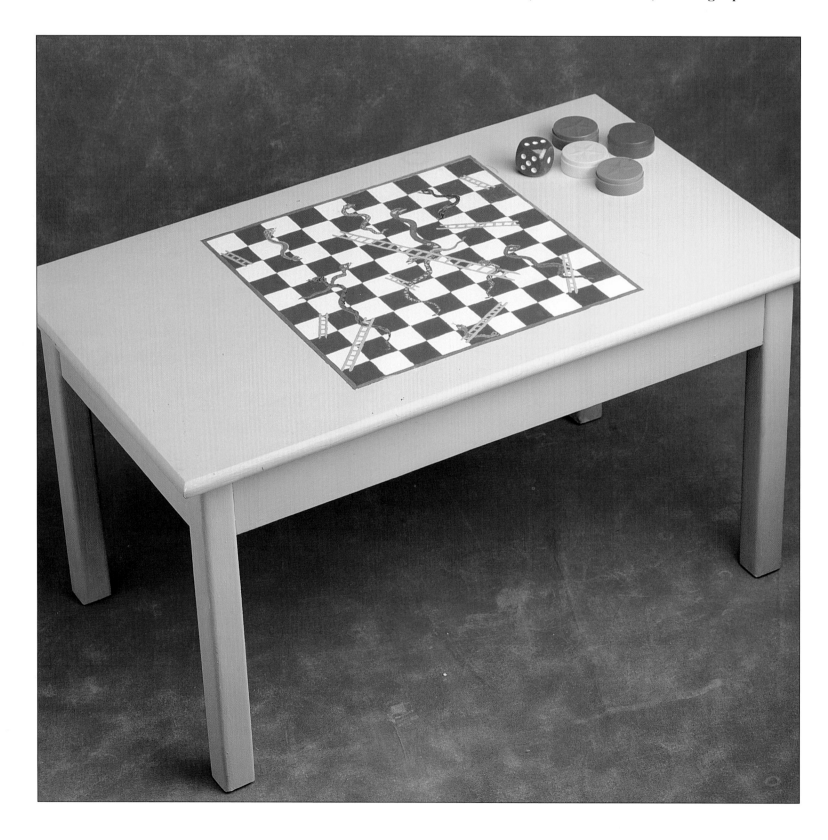

1 *Prepare the table by rubbing down with fine grade sandpaper. Paint with wood primer and leave to dry. Paint with undercoat and leave to dry. Paint the table with the satin finish paint. Leave to dry.*

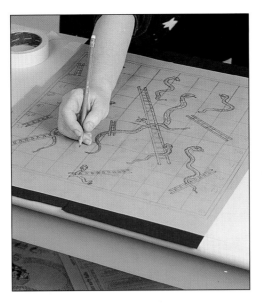

2 *Enlarge the pattern from the back of the book on to tracing paper large enough to fit your table. Tape the design on the table with a layer of carbon paper underneath. Go over the design using a pencil so that it is transferred to the table below.*

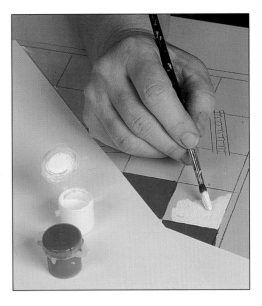

3 *Paint in alternate squares of red and white.*

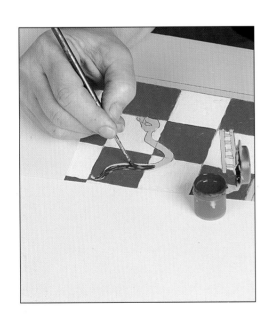

4 *Paint the snakes in bright colours.*

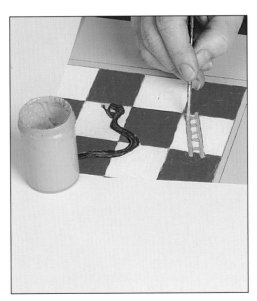

5 *Paint the ladders in bright yellow.*

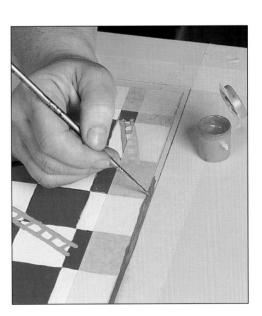

6 *Lay masking tape along the edges of the gameboard and then paint a border pattern aound its edge. As an option, paint snakes up the legs of the table. If required, add transfer numbers. Finish off the whole table with two coats of varnish.*

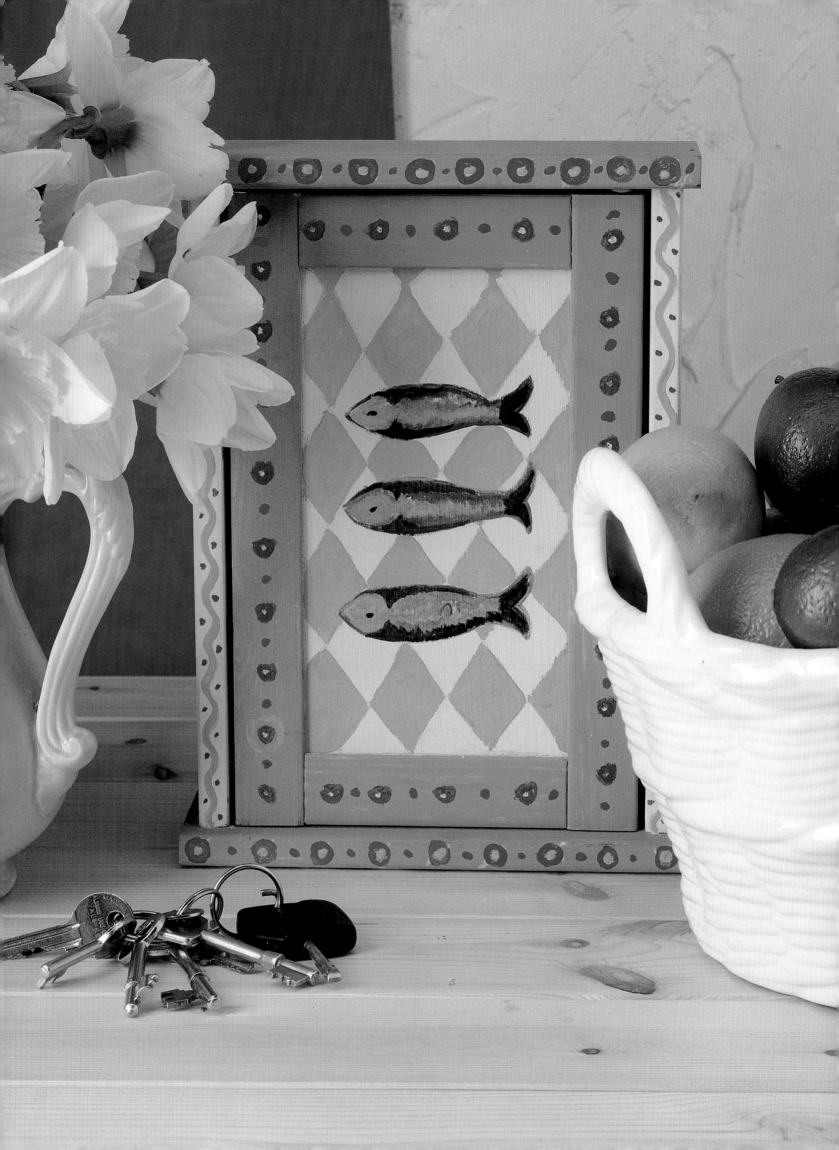

Key Cupboard

This simple cupboard can be as restrained or as highly decorated as you desire. I have chosen a design of fish set on a diamond grid with dots, dashes and wavy lines as embellishments.

Tools and materials

Paints in acrylics and emulsion

Paint brushes, Key cupboard,

Tracing paper, pencil

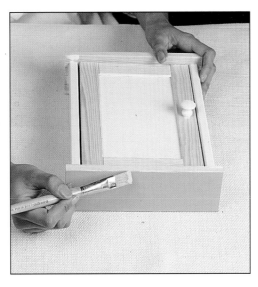

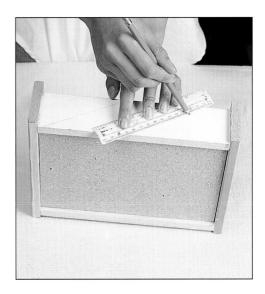

1 *Paint the sides and the front panel in pale blue.*

2 *Paint the top and bottom in a darker blue.*

3 *Draw diamond shapes on the front and sides of the cupboard using a pencil and ruler.*

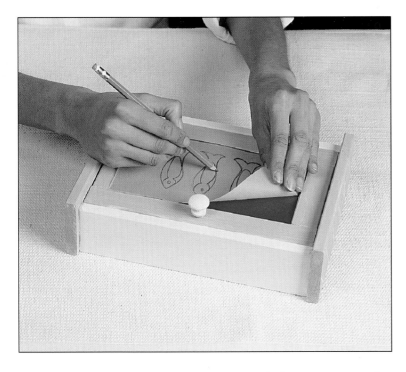

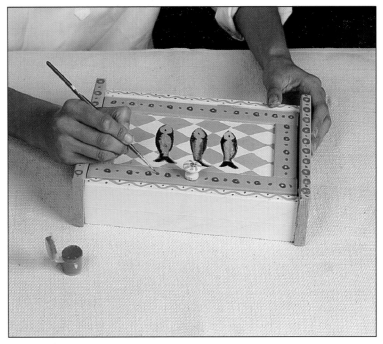

4 *Trace the fish template. Place over the diamonds, inserting a piece of carbon paper between. With a soft pencil trace off the fish.*

5 *Paint in the diamonds in yellow and the fish in greys and blacks. Add patterns round the edge of the cupboard in reds, yellows and blues.*

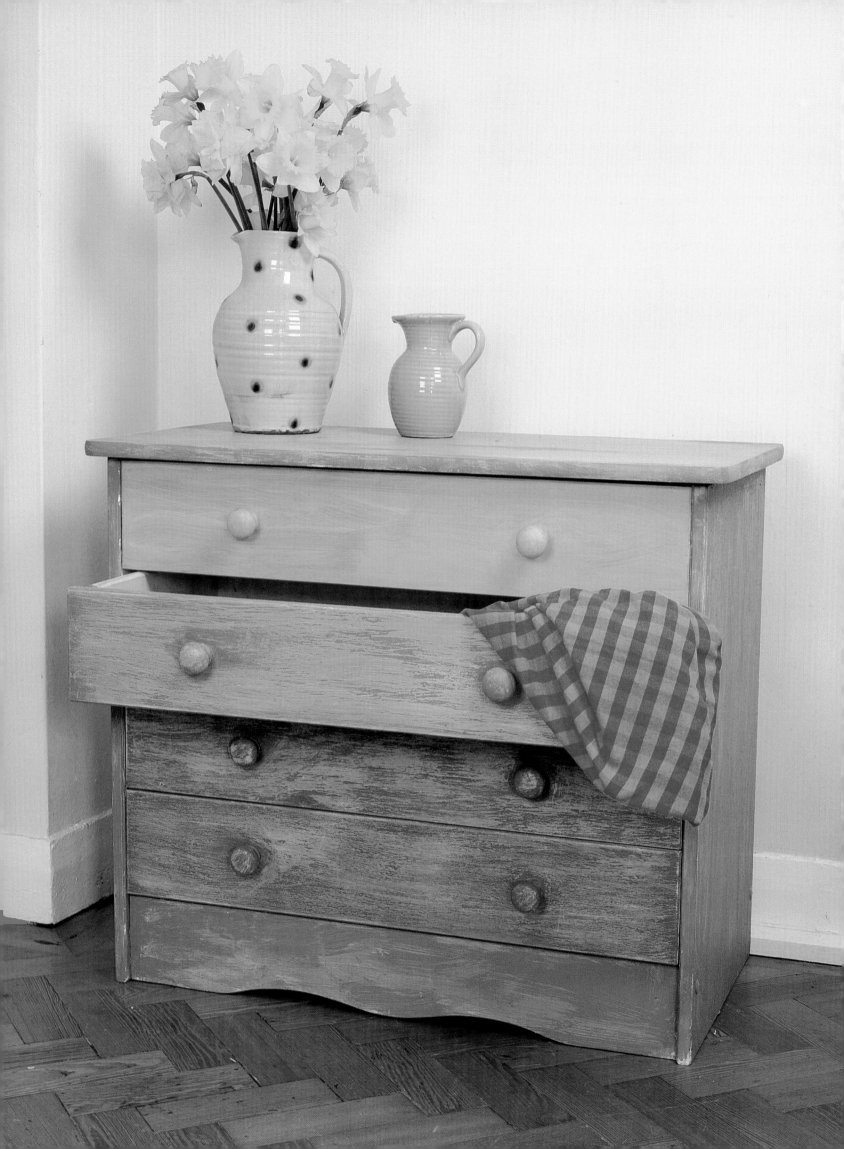

Emulsion and Wax Chest of Drawers

A shop-bought, highly varnished chest of drawers is given a treatment to distress it. Wax polish is used to create a barrier between two coats of paint which are then rubbed to create an interesting effect.

Tools and materials

Emulsion paint in white, green, blue, pink, red and purple

Paint brushes, sandpaper, wax polish and a cloth

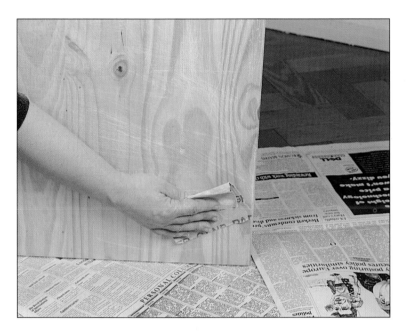

1 *Sand the entire chest of drawers with a rough grade sandpaper to break up the varnish and to prepare the surface to accept the paint.*

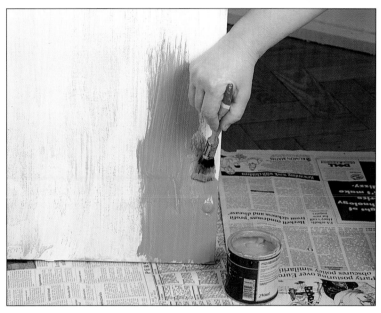

2 *Paint everything white, let it dry, and then paint it green. Leave to dry.*

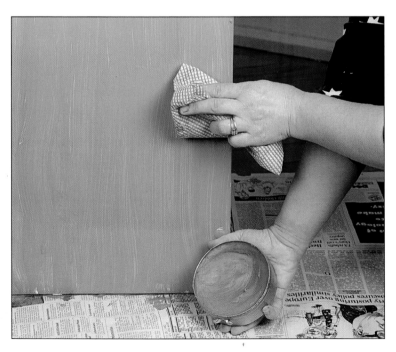

3 *Rub wax polish all over the surface. Leave to dry.*

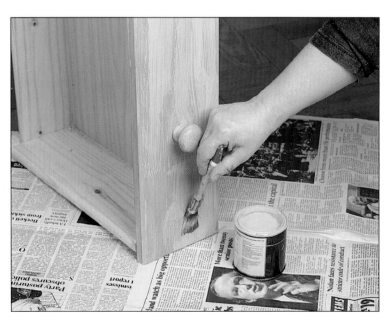

4 *Paint the frame of the chest of drawers blue and each drawer a different colour. (See main picture). When dry, rub over the whole surface with sandpaper to reveal the colour underneath.*

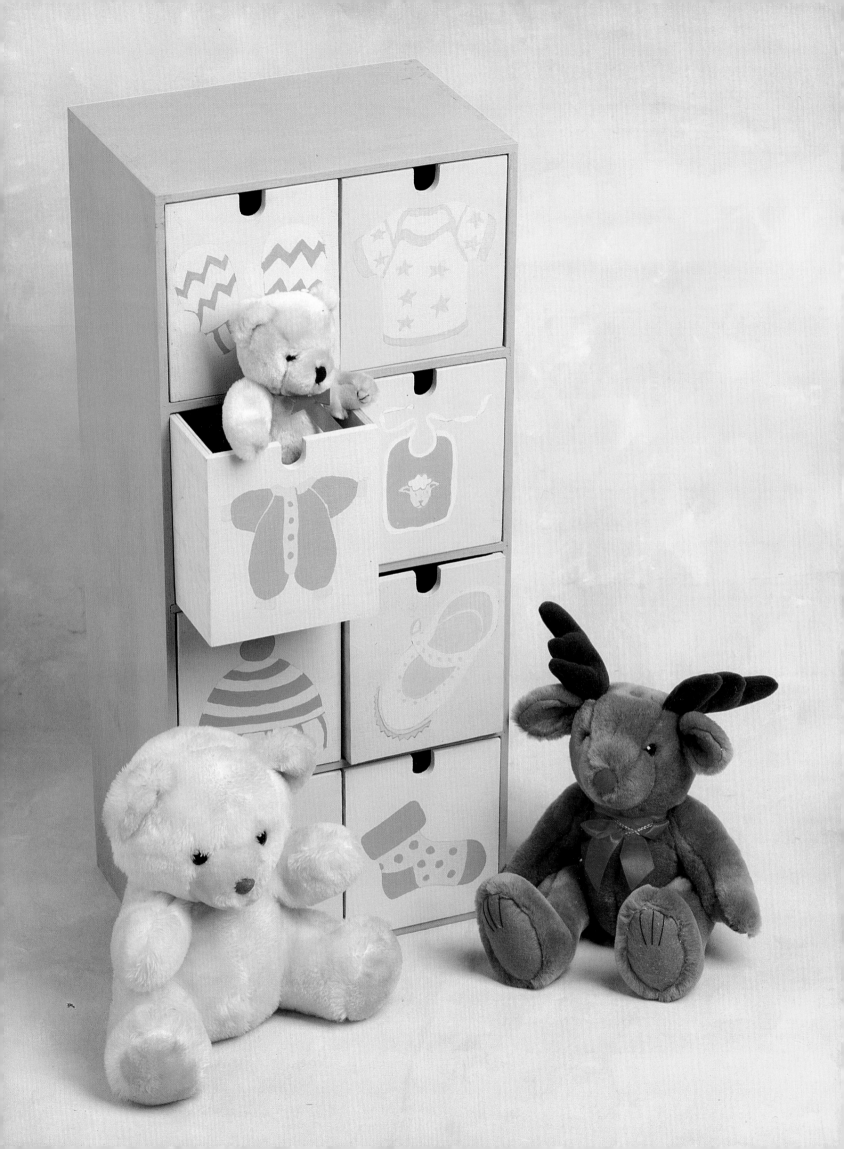

Baby's Chest of Drawers

This little chest is ideal for storing small objects of babies' clothing. Picture-coded drawers are most useful, saving you time and aggravation when looking for specific items. Draw a picture of its contents on each drawer and add a charming finishing touch to the nursery.

Tools and materials

Wooden chest of drawers, sandpaper

Satin finish paint, paint brush

Tracing paper

Carbon paper and pencil

1 *Sand down the entire chest of drawers until smooth. Paint the frame in a pale blue shade. If painting on a dark wood, first add primer.*

2 *Paint the front of the drawers in toning shades of pale colours. (See main picture).*

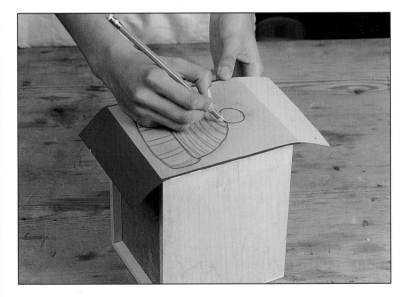

3 *Choose which objects you wish to put in each drawer. Draw the design and enlarge to the required size. Tape the design to the front of the draw with a piece of carbon paper in between. Trace over with a soft pencil.*

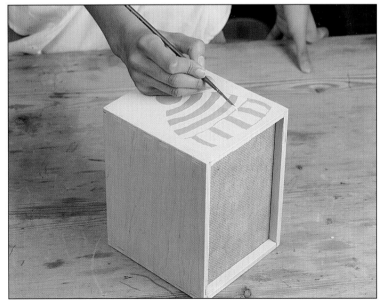

4 *Colour in the shapes using complementary soft shades. When thoroughly dry, give the whole thing a clear coat of protective polyurethane varnish.*

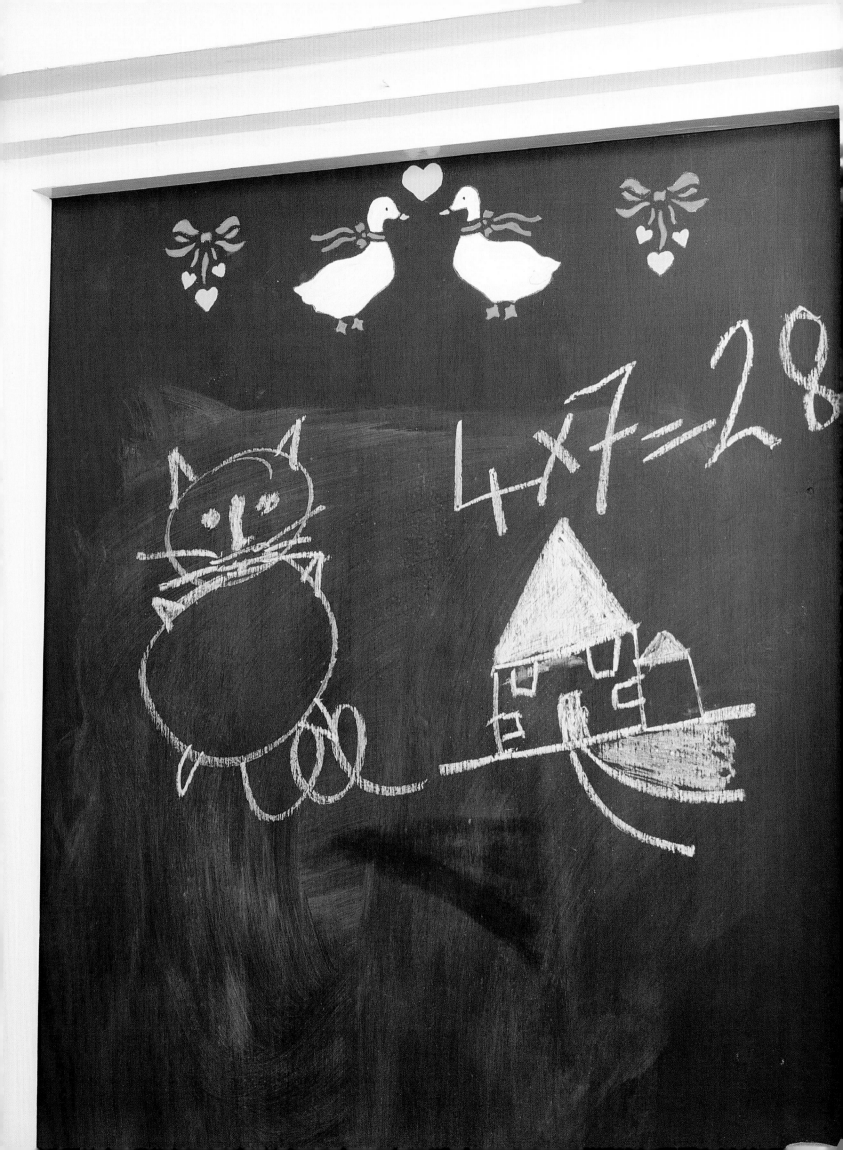

Blackboard Door

This is a great idea for a child's bedroom. Paint one side of the door with blackboard paint. Decorate the top of the door with a pretty stencilled design. (See pages 7-8).

Tools and materials

Blackboard paint, decorator's paint brush

Stencils, white emulsion, stencil brush

Coloured emulsions

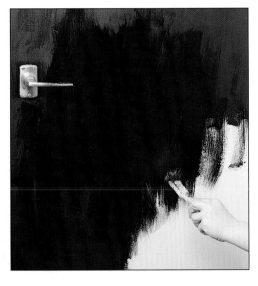

1 *Paint the door with two coats of blackboard paint, leaving to dry between coats. Leave to dry .*

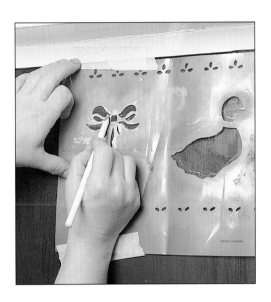

2 *Tape your chosen stencil design to the door. With a white pencil, stencil through. Remove stencil.*

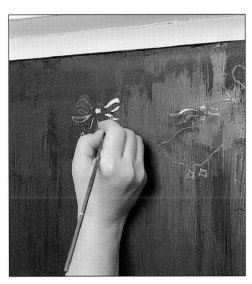

3 *Block in all the images in white. Leave to dry.*

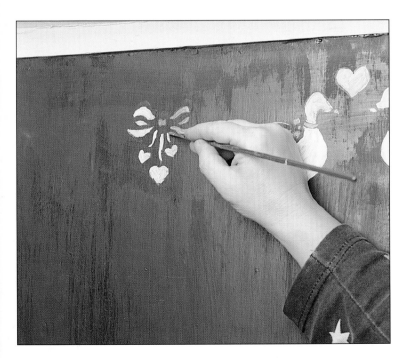

4 *Leave the birds white and paint the ribbons green.*

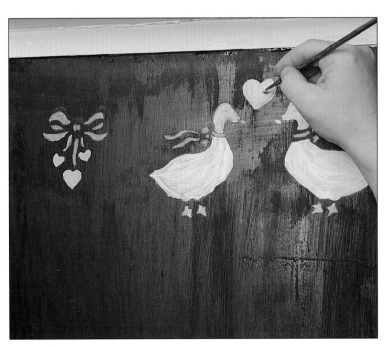

5 *Paint the hearts pink and the birds' feet and beaks orange.*

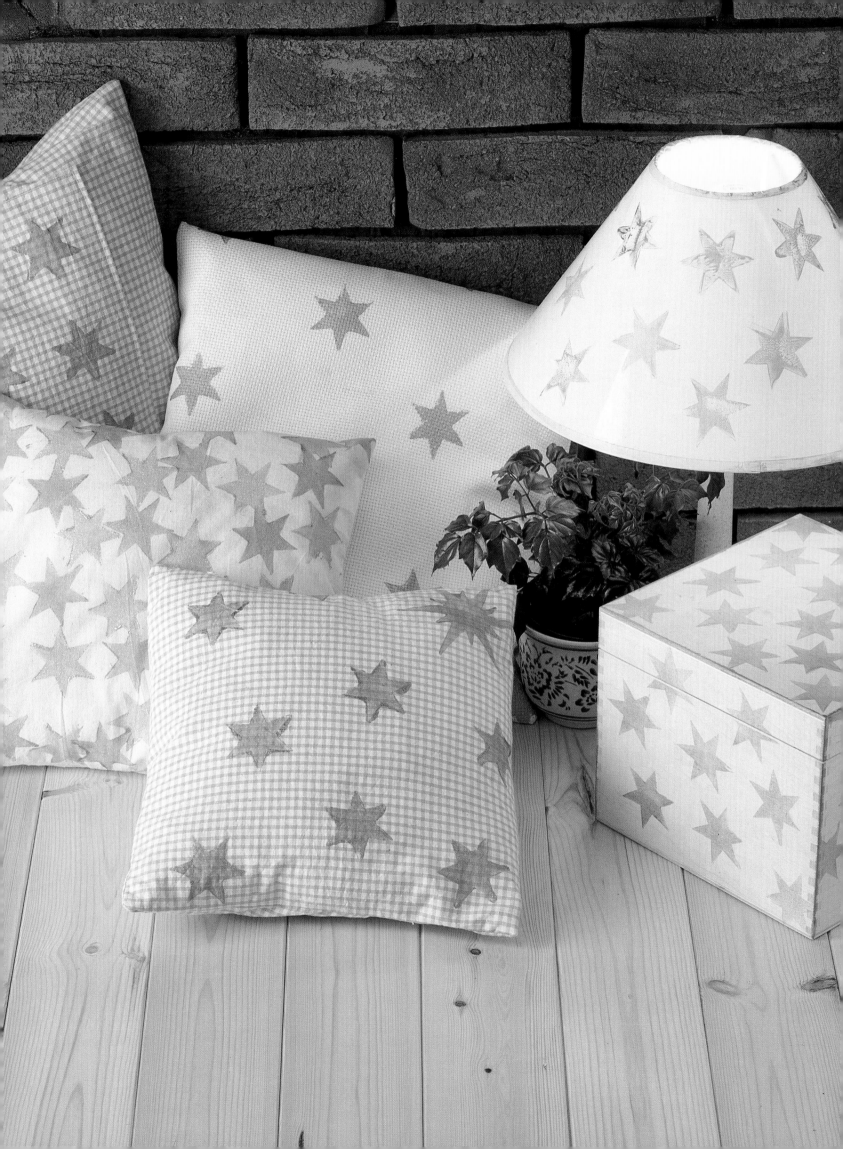

Stamped Box and Accessories

Stamping is an easy way of decorating any surface and produces a dramatic and striking effect. Stamps can be made of rubber, cork or plastic. They can be purchased from toy shops or specialist decorating shops.

Tools and materials

Paint. (See pages 7-9 – choosing the right paint)

Sponge roller (a small decorator's roller will do)

A wooden box, a stamp (bought or made), saucer

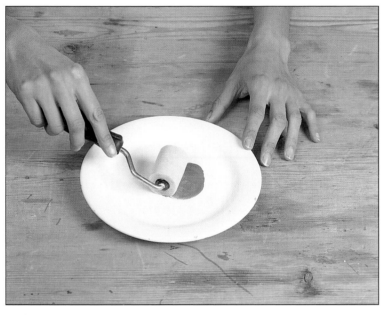

1 *Pour a little paint into a saucer and thoroughly coat the roller in it.*

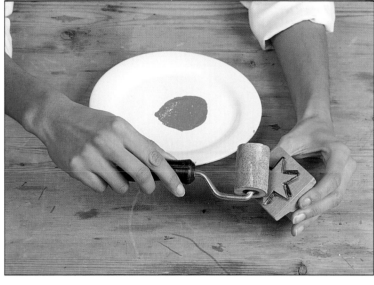

2 *Using the roller, cover the stamp evenly with paint.*

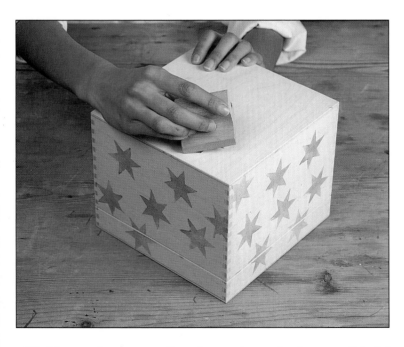

3 *Press the stamp firmly against the box and hold for a few seconds. Remove without smudging. Repeat the process in the next position.*

4 *When the box is covered in the design, dip a finger in the gold paint and rub along the edges to make a good finish. Use this method to decorate the other items in the main picture.*

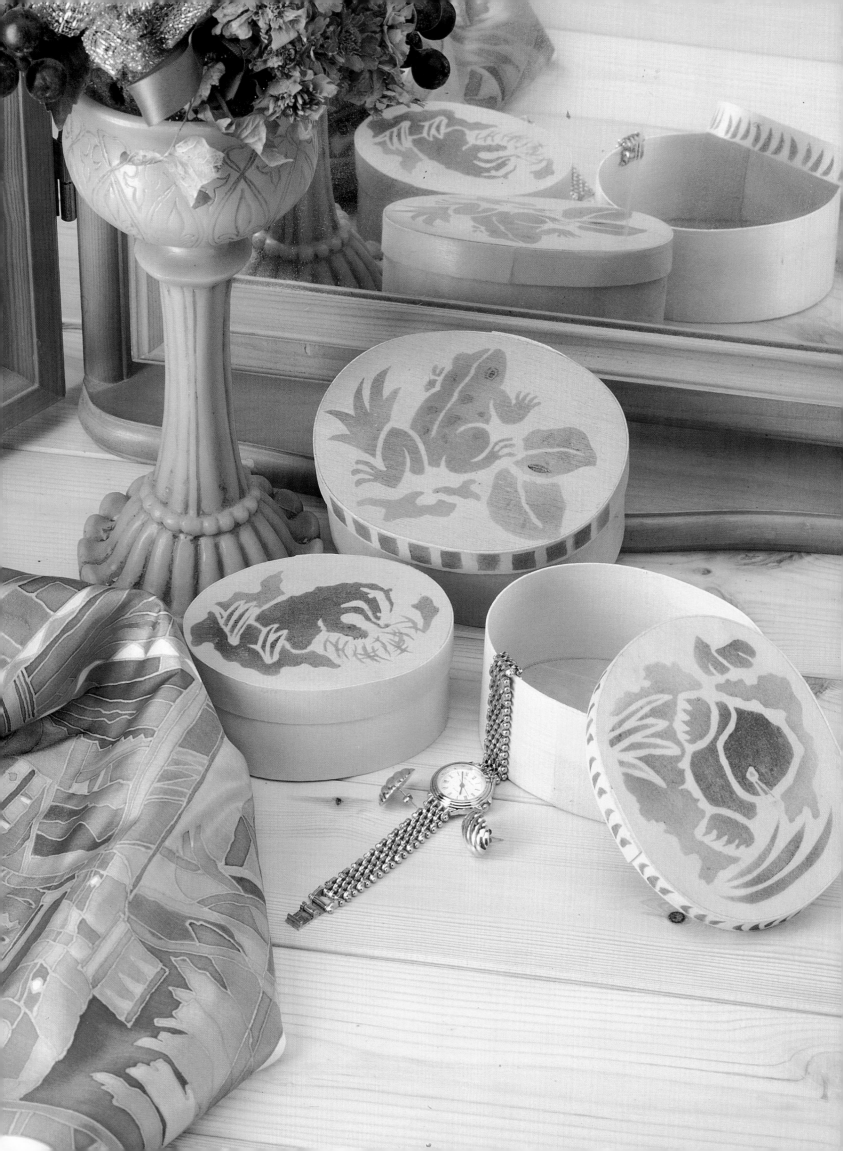

Stencilled Animal Box

These little boxes make pretty dressing-table accessories for jewellery or small trinkets. This form of stencilling, using oil-based pencils, is simple to do and produces an interesting effect, the colours blending together easily with no smudging.

Tools and materials

Oil-based stencil pencils (available from craft shops)
Wooden boxes, tracing paper, pencil, thick brush
Craft knife, pattern from back of book

1 *Trace the mole stencil from the back of the book.*

2 *Cut out stencil with a craft knife.*

3 *Break seal of the end of the oil-based stencil pencil and rub a little onto a piece of the tracing paper.*

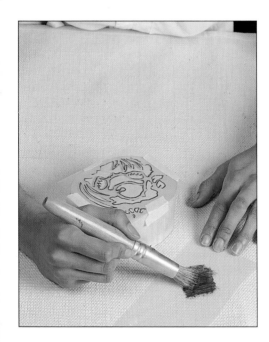

4 *Load the colour onto a thick artist's brush.*

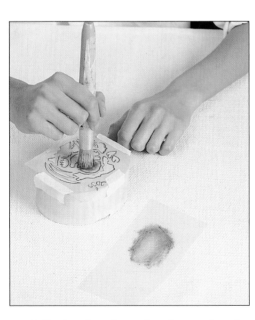

5 *Rub the brush through the stencil in a circular motion until area is covered.*

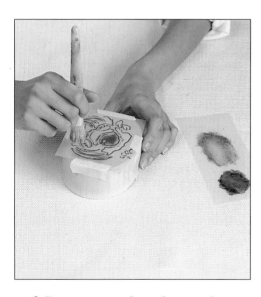

6 *Repeat with other colours. Colours are simply blended, but use a clean brush for each to prevent colours from going muddy.*

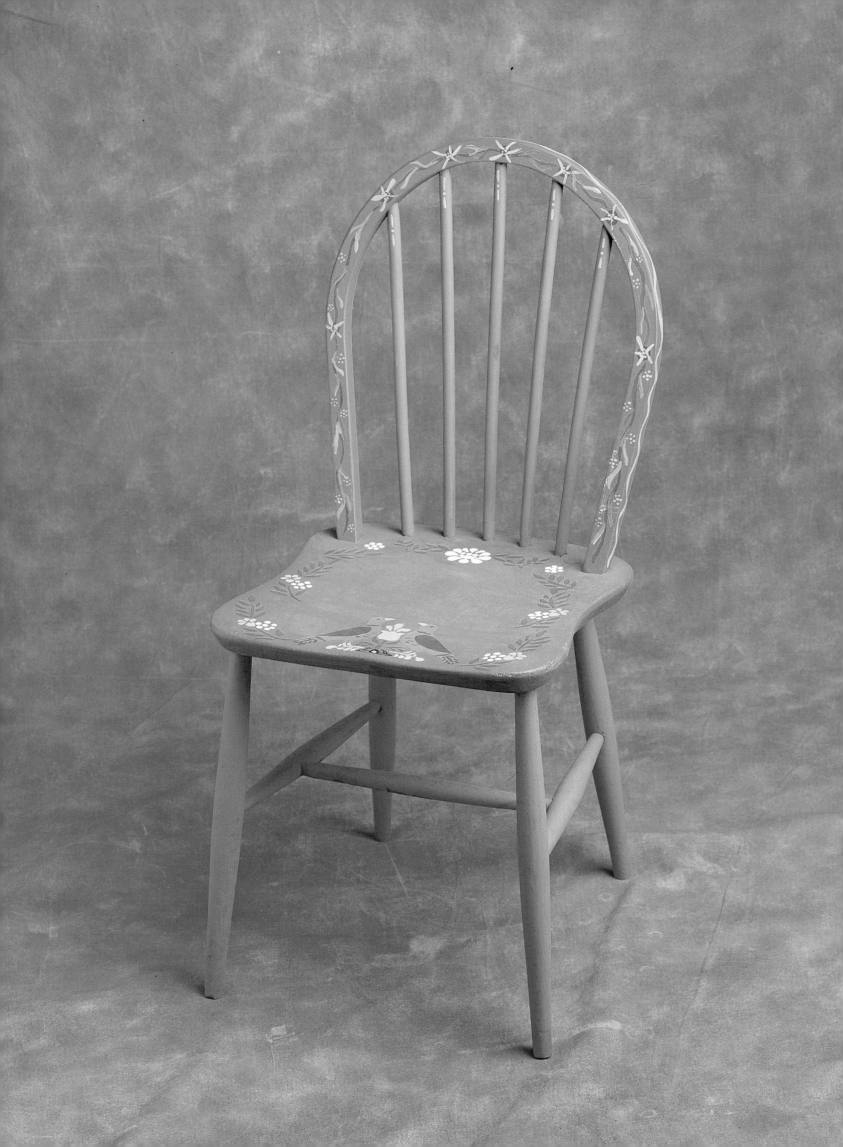

Mexican Chair

This is a great way of giving new life to an old wooden chair. The style and colours are Central American, so either follow our patterns or create your own using very bright colours. Either use quick-drying acrylics and finish with a coat of varnish, or use satin finish paint.

Tools and materials

Old chair, paint stripper or other paint remover

Scraper, wire wool, paints, artist's paint brush

2-inch decorator's brush, rubber gloves, pencil

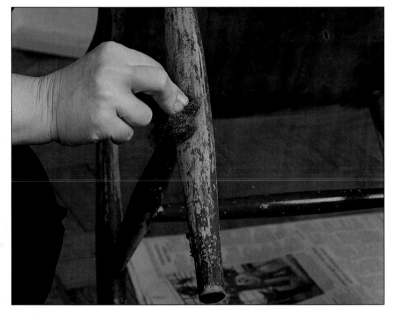

1 *Cover an old chair with paint remover and leave to work according to the manufacturer's instructions. Remove, using a scraper and wire wool.*

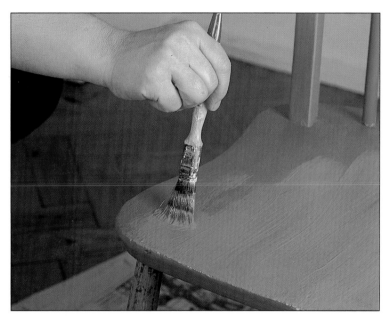

2 *Paint on the base coat. This could be one colour for the seat and a different colour for the uprights and legs.*

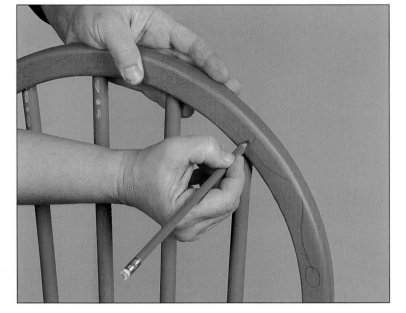

3 *Using a soft pencil, draw in the designs on the chair, rubbing out any mistakes you make.*

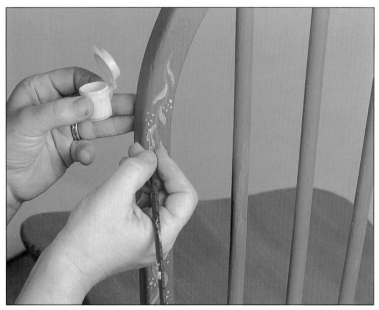

4 *Paint over the pencil lines and fill in with the colours of your choice.*

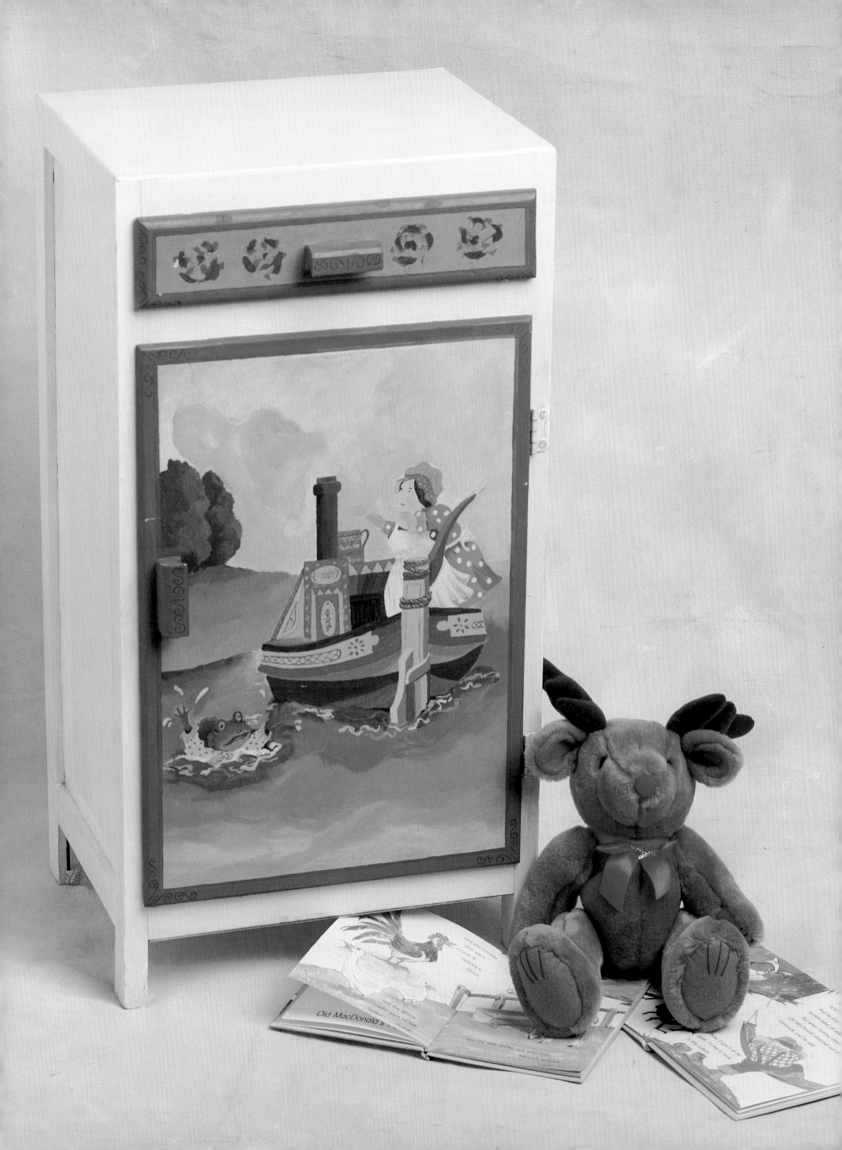

Wind in the Willows Cupboard

The scene painted on this cupboard door is the famous one from *Wind in the Willows* when toad falls into the river dressed as a washerwoman.

Tools and materials
Cupboard to paint
White satin finish paint, acrylic paints
Decorator's paint brush, artist's paint brush
Carbon paper and pencil

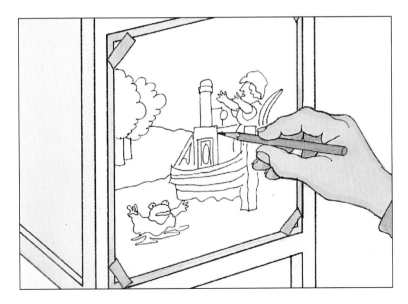

1 *Prepare the cupboard by sanding, priming and undercoating, then paint in white satin finish paint.*

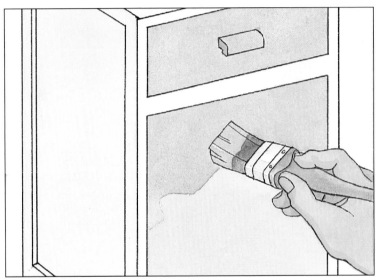

2 *Paint the front panel of the cupboard in light blue.*

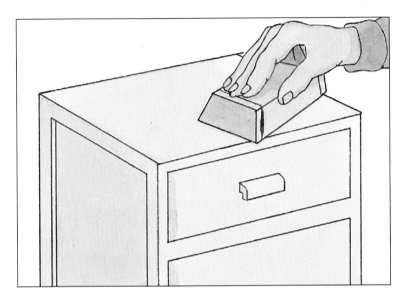

3 *Photocopy the design from the book and enlarge it so that it will fit your cupboard. Tape the design, with a piece of carbon paper underneath, onto the front door of the cupboard. Trace over the design with a pencil.*

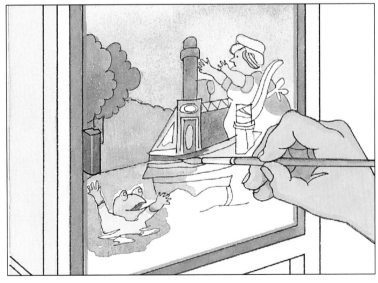

4 *Remove the carbon paper and the design and, following the colours from the photograph, paint the design onto the cupboard. Paint the edge dark blue with a line of gold to highlight it.*

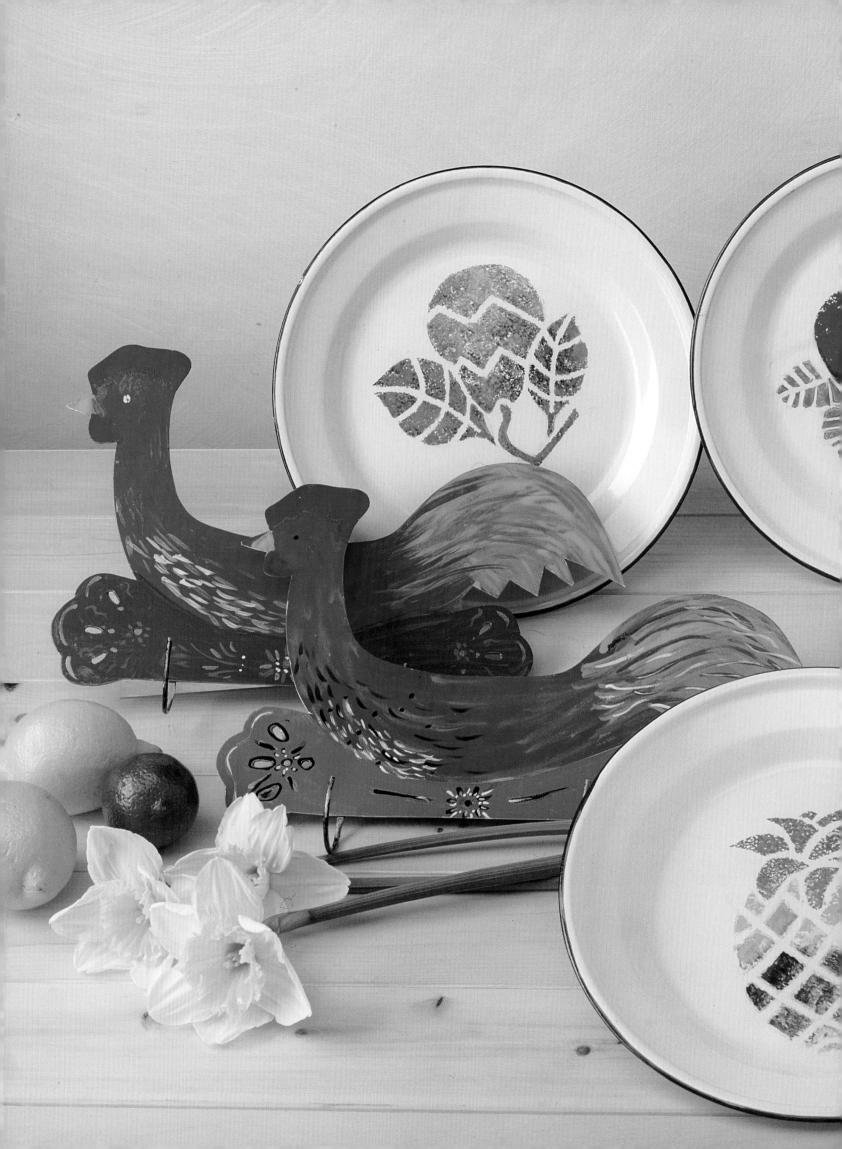

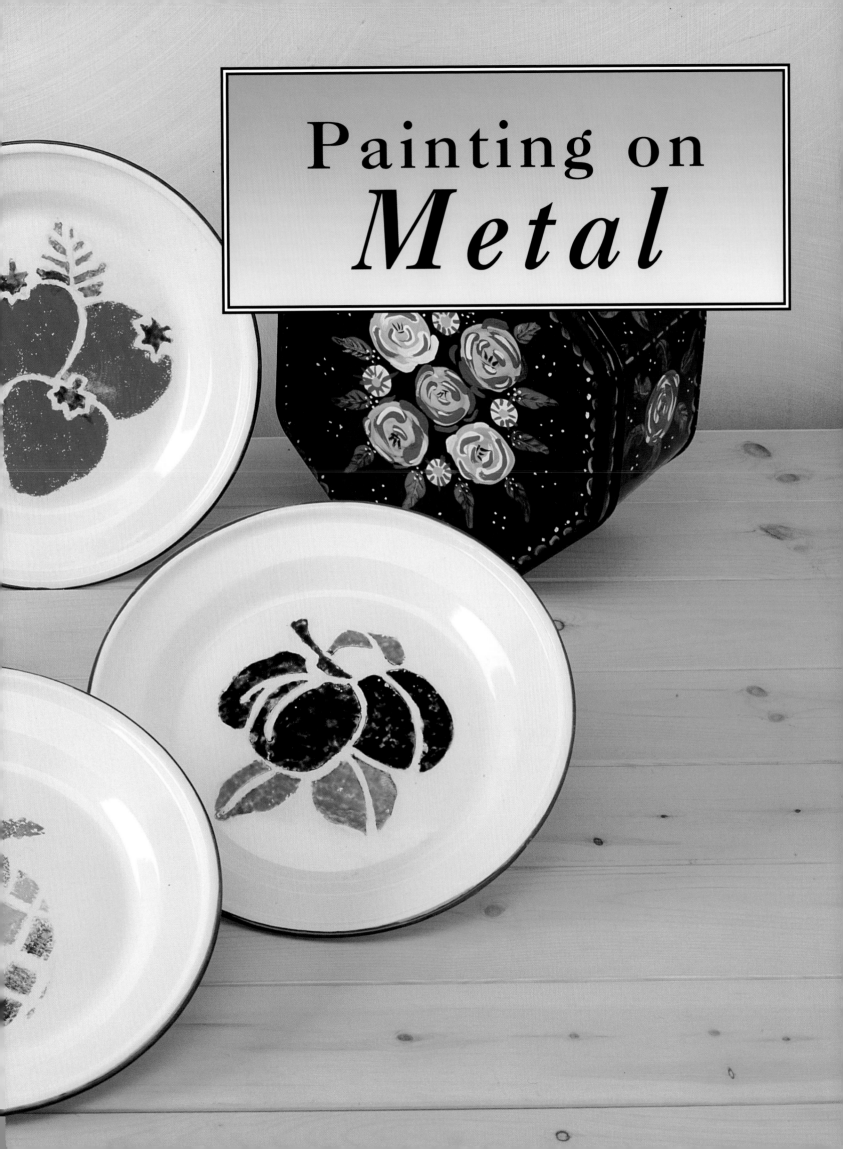

Painting on *Metal*

Although the inspiration for our metal box comes from the style of narrow-boat painting popularized by the waterway travellers of England, painted tinware is also popular in China and the Slavonic nations of Eastern Europe. Narrow-boat painting was traditionally applied to three basic utensils: the Buckby can – a covered watering can used for holding drinking water, a hand bowl which was used for scooping canal water for washing and a nosh bowl from which the canal horse ate his oats.

The style of narrow-boat painting is often known as 'castles and roses' because these are the most popular images used. Roses were popular because they grew along the tow paths of the canal. The castles are thought to resemble those of the Carpathian Mountains of Eastern Europe. Your tin will need a base colour before the design is applied. The easiest way to describe narrow-boat painting is to say that the design is built up in layers, e.g., starting with the background colour, the base colour for leaves and roses and then the fine details.

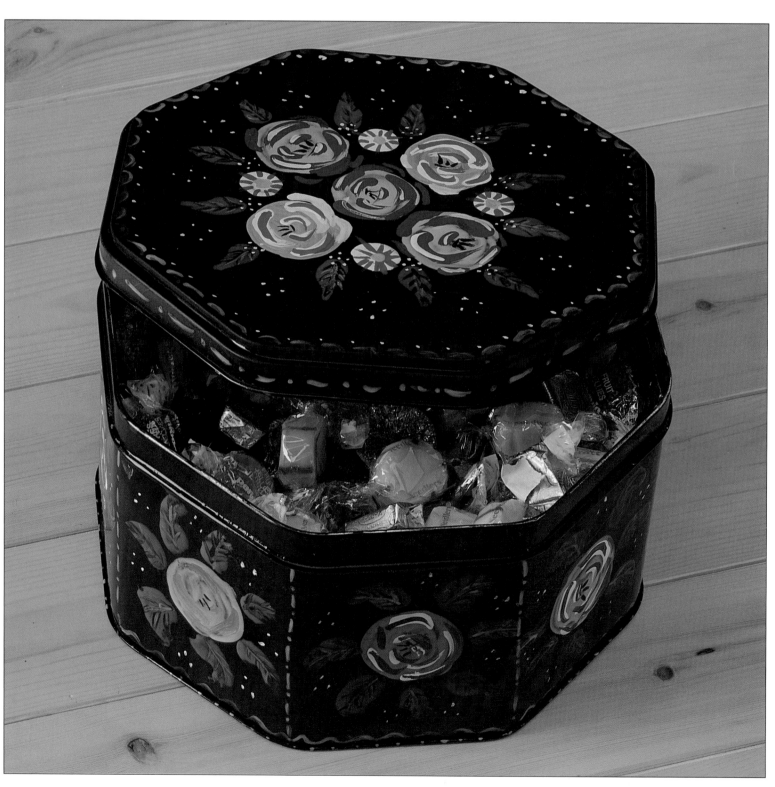

Canal Boat Style Metal Box

1 It is a good idea to practise on an old piece of metal before starting on the project.

2 The secret of authentic-looking canal art is to apply the strokes in a free, loose-wristed manner.

3 You can use ceramic, enamel, or cellulose paints on metal. They all give a shiny finish, but do not mix the two together.

Tools and materials

Metal box to paint, a selection of brushes

Varnish, sandpaper, black paint spray

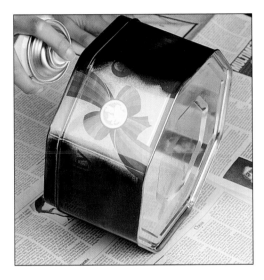

1 Sand down the box until it is smooth and clean. Spray the background in black. When dry, rub down with fine sandpaper.

2 Paint the base design for the roses and the leaves in free hand. Leave to dry.

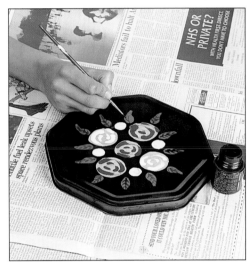

3 Paint in the petals and the leaf markings with single, swift, brush strokes using a fine brush.

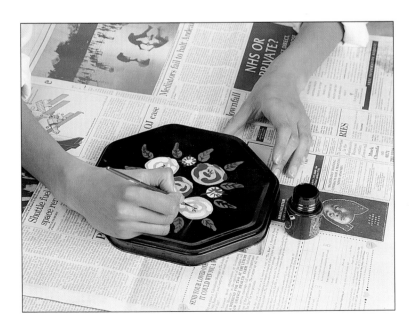

4 Add dots and dashes for the flower centres using an even finer brush. Leave to dry.

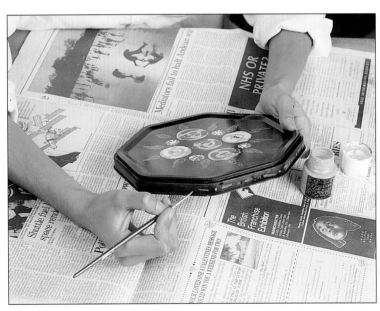

5 Add the border pattern. When all the paint is dry, finish with a coat of clear varnish.

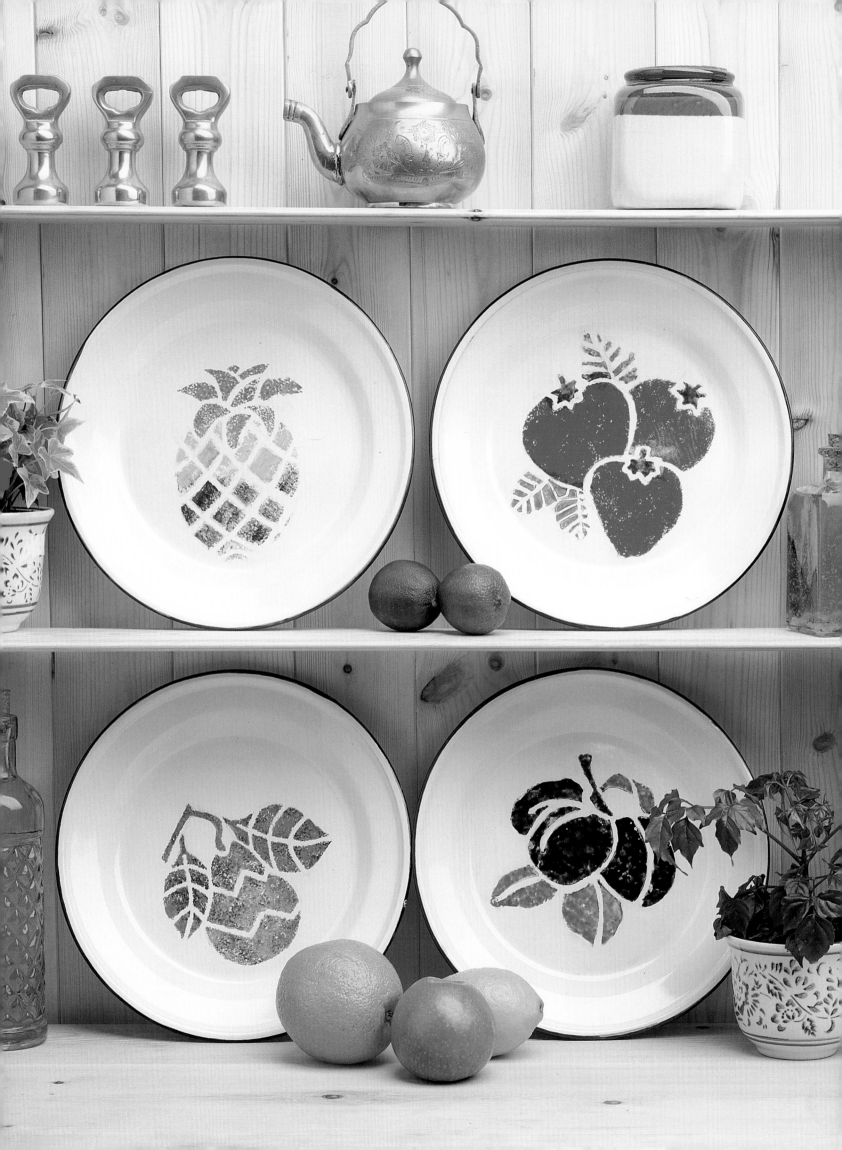

Fruity Plates

A simple way to decorate inexpensive enamelware. Make a fruit design and cut a stencil to transfer it on to the centre of the plate. Alternatively, fruit stencils are popular at the moment and can easily be bought from craft and decorating shops.

Tools and materials

Ceramic paints, sponge, paper and pencil

Acetate, craft knife and cutting mat, masking tape

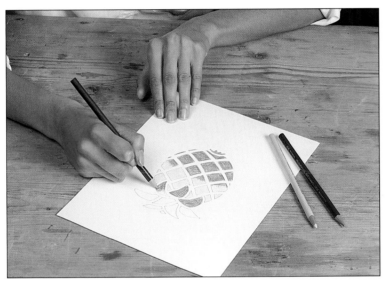

1 *Draw your design onto paper, indicating the colours. Place the acetate over the design and trace through, using a permanent marker.*

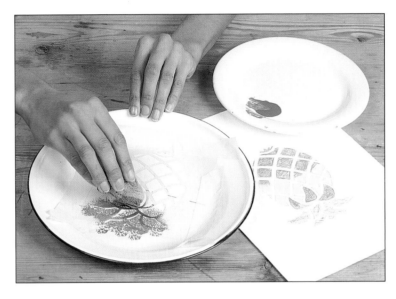

2 *Cut out the design with a craft knife. Tape the stencil onto the plate and pour some glass or ceramic paint into a bowl. Dip the sponge into the green and stamp off the leaf design.*

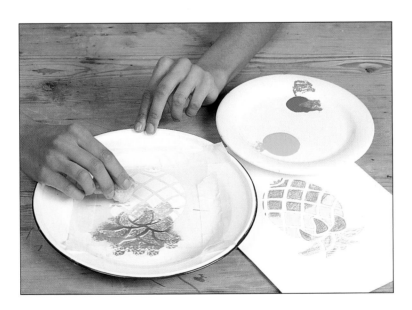

3 *Use a fresh piece of sponge to paint in the yellow colour overlapping the green in places.*

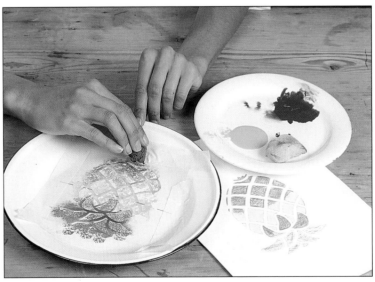

4 *Dip another piece of sponge into the brown and finish off the pineapple. Leave to dry.*

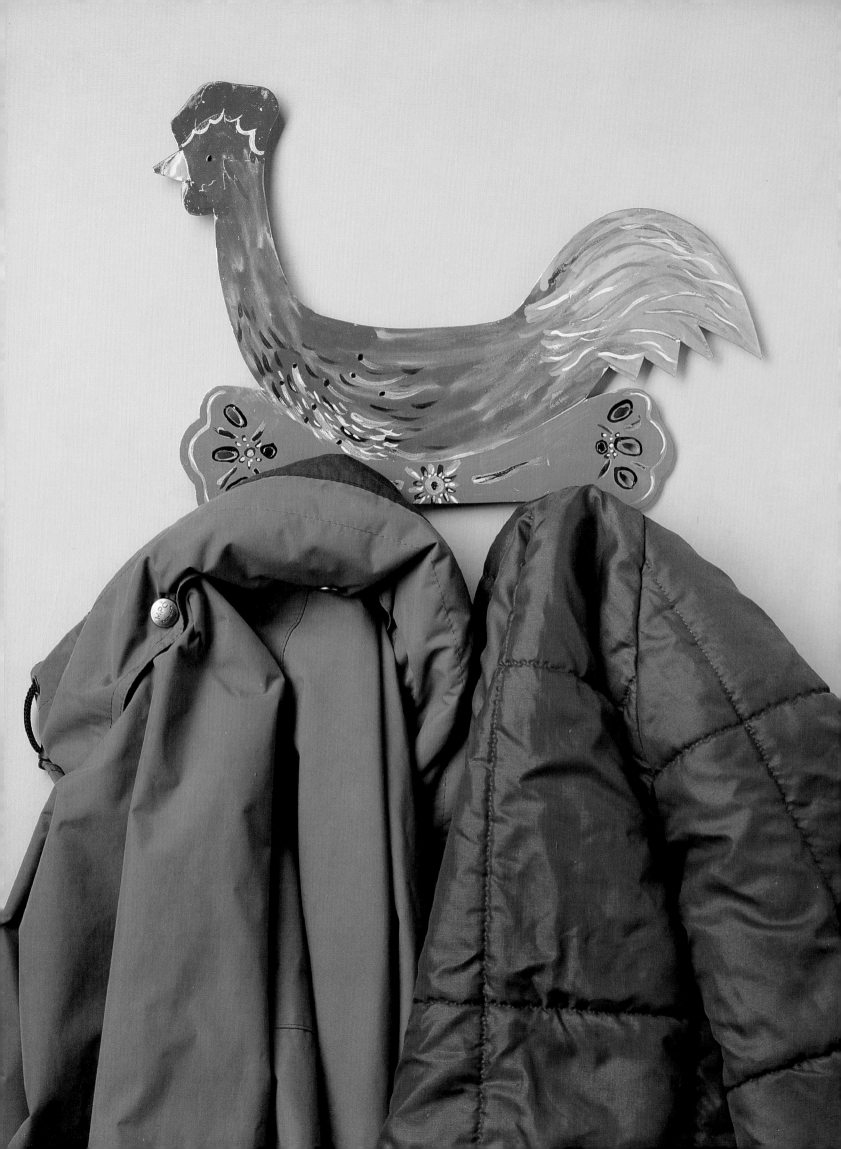

Cockerel Coat Hook

This metal cockerel was purchased in a department store. However, if you can't find one, you can cut one out of a sheet of aluminium using tin snips. Cut off part of a coat hanger and solder them into position as hooks.

Tools and materials

Metal birds, metal or glass paints

A variety of paint brushes, turpentine for cleaning sponge, wire wool

1 *Rub the background with wire wool and turpentine to give a clean surface to work on.*

2 *Paint the background colour for the cockerel's head and body.*

3 *Paint in the cockerel's comb*

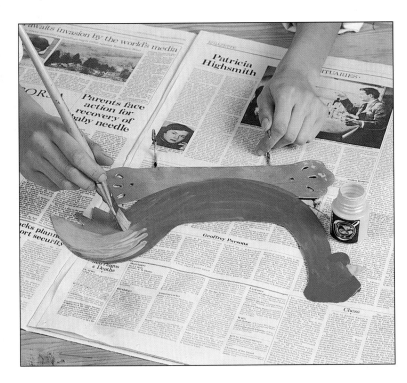

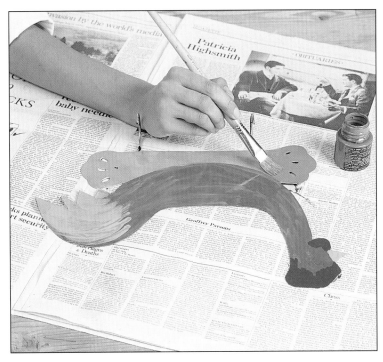

4 *Paint in the tail feathers and beak.*

5 *Paint the base on which the cockerel sits with patterns and flowers.*

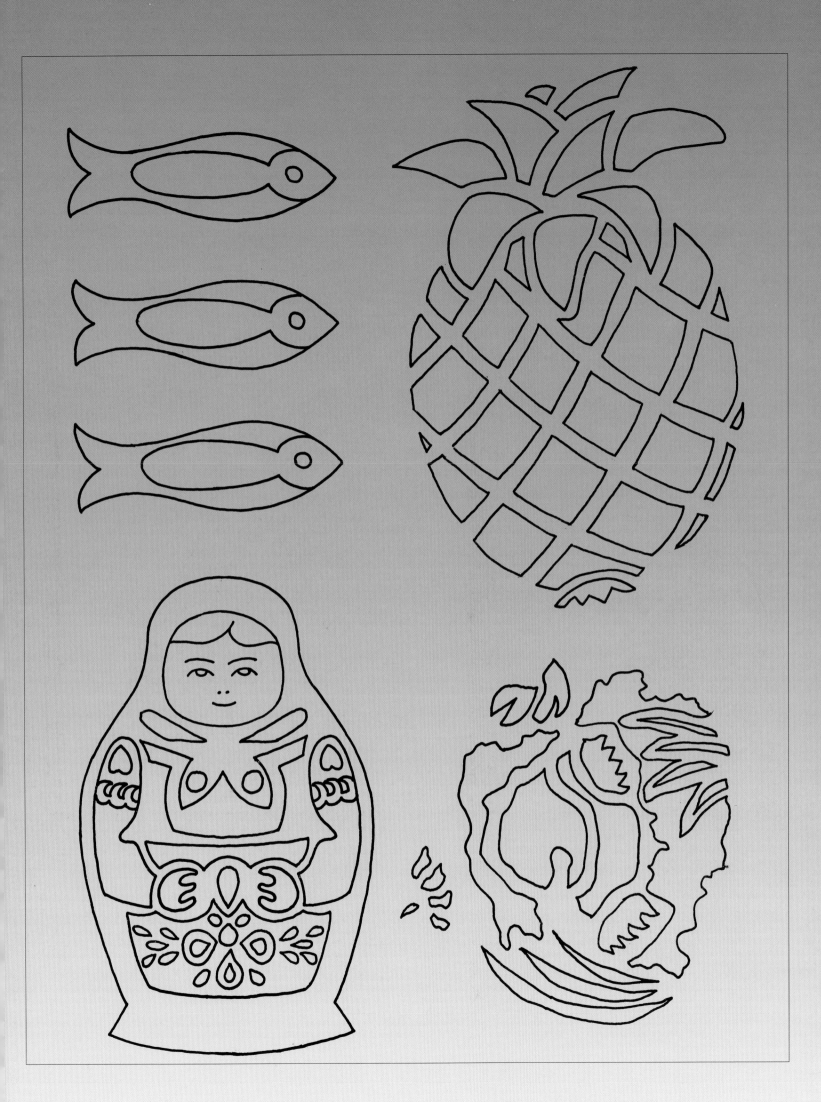

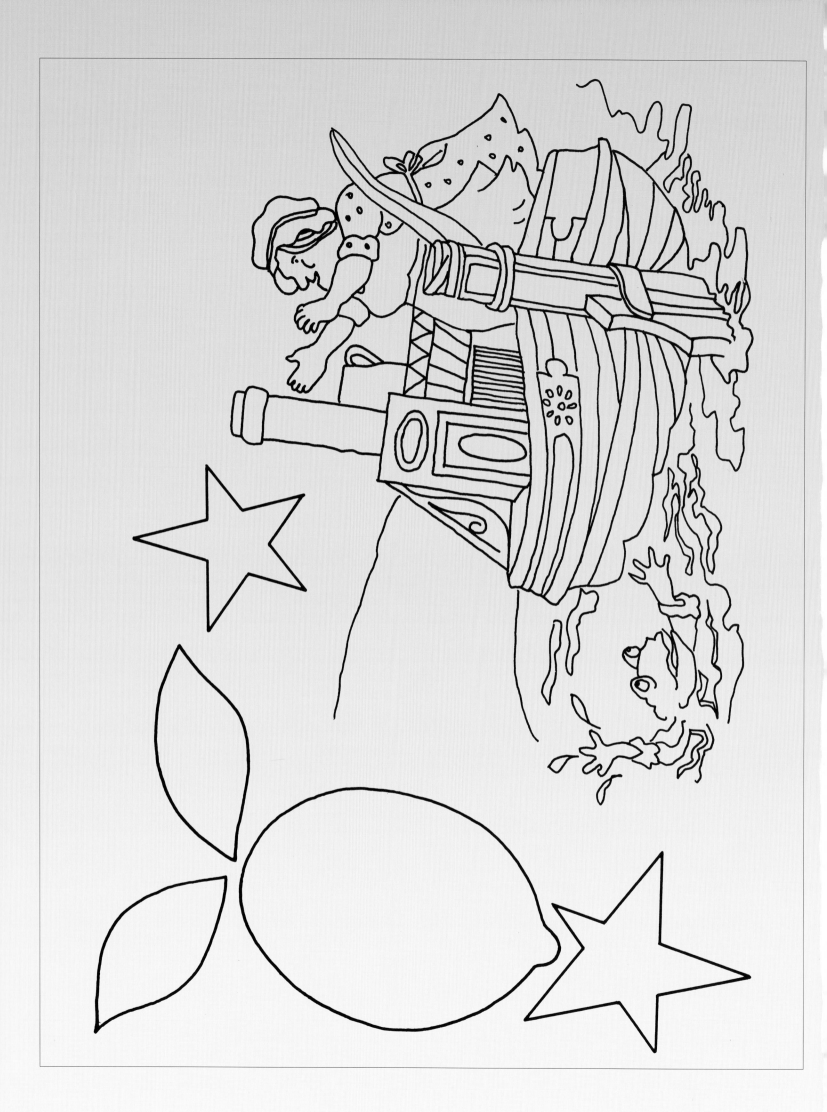